IMAGES
of Rail

NORFOLK AND WESTERN RAILWAY

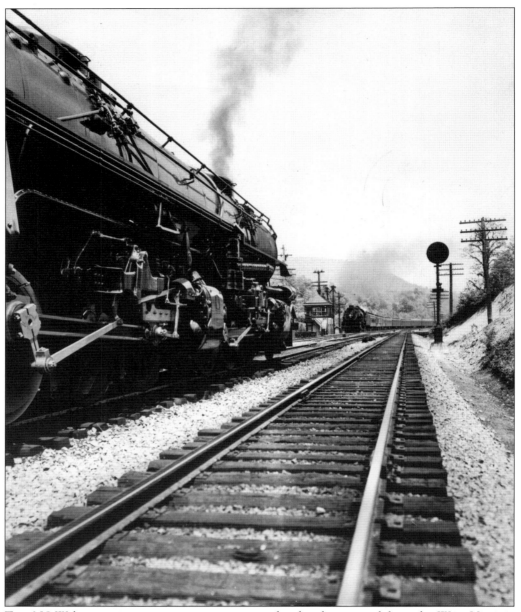

Two N&W locomotives prepare to pass one another heading to and from the West Virginia coal fields. (VMT Inc., Archival Collections.)

IMAGES
of Rail

NORFOLK AND
WESTERN RAILWAY

Nelson Harris

ARCADIA

First published 2003
Reprinted 2003, 2004

Published by Arcadia Publishing
Charleston SC, Chicago, Portsmouth NH, San Francisco

Printed in Great Britain

Library of Congress Catalog Card Number: 2003103301

For all general information contact Arcadia Publishing at:
Telephone 843-853-2070
Fax 843-853-0044
E-Mail sales@arcadiapublishing.com

For customer service and orders:
Toll-Free 1-888-313-2665

Visit us on the internet at http://www.arcadiapublishing.com

To my father, Charles C. Harris, a retiree of the N&W Railway.

CONTENTS

ACKNOWLEDGMENTS

I am grateful to a number of persons who assisted me in bringing this book to print. I am most appreciative of the staff and editors at Arcadia Publishing, especially my editor Kelle Broome, for their encouragement and guidance. Kirk Lashley provided technical assistance but his friendship is of more value. This book would not have been possible without the enthusiastic cooperation of the Virginia Museum of Transportation (VMT) in Roanoke, Virginia. Unless otherwise noted, the images within this book come from the extensive Norfolk & Western Railway archives housed at the Museum. In particular, I am grateful to the support of VMT's executive director, Kay Strickland, and to the director of operations, Carolyn Payne. Carolyn and Kay's support was immeasurable and invaluable. Of interest to readers is the availability of reprints of photographs included in this volume. For information on reprints and other archival material, persons may contact

Virginia Museum of Transportation
303 Norfolk Avenue
Roanoke, Virginia 24016
540.342.5670
www.vmt.org

INTRODUCTION

Railroads have rhythm. On the summer nights of my boyhood, I could hear it—the rhythm. With bedroom windows open to catch a breeze, I would lie still and listen to the railroad. My family did not live close to the tracks, but we were close enough. Close enough to hear the train cars being hooked together. The muted, muffled sound of metal meeting metal. Close enough to hear each car shift from stillness to motion as the engine began to pull the consist forward. Close enough to vaguely hear the click-click-click of wheels revolving over rail. What better sounds to escort one to sleep.

The rhythm of the railroad, like that of a symphony, is the creation of many. Blacksmiths, carpenters, clerks, yard masters, conductors, attorneys, upholsterers, commercial agents, steel workers, rail splitters, accountants, and laborers contributed to the score. The rhythm of the Norfolk and Western Railway began in 1881 and continued for a century until its merger with the Southern Railway. Photographs depicting that century are in this volume. Collected from the N&W archives of the Virginia Museum of Transportation, they visually tell the story from the earliest days of railroad through its development into one of the major transportation companies in the United States.

The Norfolk and Western took the railroad rhythm to the coal fields of West Virginia, where depots became towns, and towns became small cities. Through the vision of its presidents and the access of its rails, the Norfolk and Western Railway spurred the efforts to discover and develop the "black gold" veins running below the mountains, creating jobs for thousands of miners.

The Norfolk and Western provided passenger service to major metropolitan areas as well as to rural villages. The passenger coach, dining service, lounge car, and all the other amenities have become part of a romanticized past for many. Packed with travelers, especially during World War II, many of the passenger stations have been converted for other uses, if they are still even standing.

The Norfolk and Western era began in failure. The bankruptcy of the Atlantic, Mississippi & Ohio Railroad resulted in an auction at Richmond, Virginia, on February 10, 1881. A little-known and stoic Clarence Clark of Philadelphia staked his family's financial fortune on the purchase of the railroad with a winning bid of $8,505,000. Immediately upon purchase of the AM&O, Clark and his brothers changed the name to the Norfolk and Western Railroad for reasons never fully known. Hauling primarily cotton during its first years, the N&W would develop the vast coal reserves in West Virginia a decade later. And the rest, as they say, is financial history.

If a picture is truly worth a thousand words then this volume of some 200 prints is an enormous text. They can only tell, however, a portion of the story. This work is by no means intended to be a thorough or authoritative resource on the subject. Many others have taken specific aspects of the N&W operations and done them justice through valuable and detailed research. *Images of Rail: Norfolk and Western Railway* is an effort to broadly capture and visually interpret the century-long biography of one of America's great railroads through the lens of archival photographs.

As the author, the story of the Norfolk and Western Railway is the story of my home community. It grew and prospered with the railroad. The tracks of the N&W snake through its heart. Its architecture, economy, and institutions have been shaped by what a Philadelphia banker purchased that raw Richmond morning in 1881. While the N&W is no more, and the merger with the Southern Railway caused the headquarters and some shop operations to move, much of the N&W is still here. And on a summer night, with a window open, one can become a boy again. You can still hear it—the rhythm.

Nelson Harris
Roanoke, Virginia

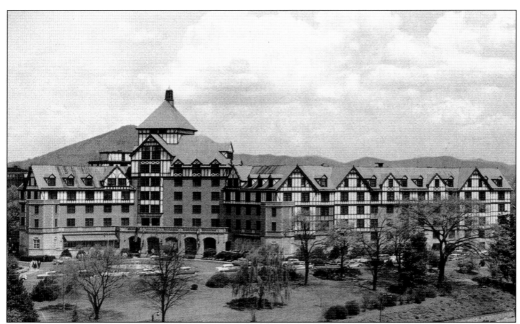

This 1960s photograph shows the famed Hotel Roanoke, a 425-room Tudor-style hotel built and managed by the Norfolk and Western. Adjacent to the former headquarters buildings, the Hotel Roanoke was originally built in the late 1880s to serve the railway's passengers and officials. The remodeled Hotel Roanoke remains a signature facility in the cityscape of Roanoke, Virginia. (VMT Inc., Archival Collections.)

One

IN THE BEGINNING

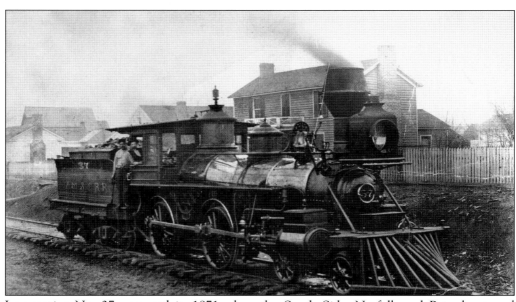

Locomotive No. 37 was used in 1871 when the South Side, Norfolk and Petersburg, and Virginia and Tennessee Railroads were consolidated, forming the Atlantic, Mississippi and Ohio Railroad. The AM&O was the forerunner of the Norfolk and Western Railway. (VMT Inc., Archival Collections.)

Office Atlantic, Miss. & Ohio Rail Road.

LYNCHBURG, VA., JUNE 1st, 1871.

NOTICE.

I. Passengers for

RICHMOND, BALTIMORE, PETERSBURG, PHILADELPHIA, NORFOLK, NEW YORK, *VIA NORFOLK*

AND

Do not change cars at Lynchburg. Tickets on sale for the above points at the Company's ticket office, Lynchburg, at rates lower than by any other route. **25 minutes allowed for breakfast at Lynchburg.** Daily connections made for above points (except on Sundays) for **BALTIMORE, PHILADELPHIA** and **NEW YORK**, at *Norfolk*.

II. PASSENGERS GOING NORTH

Via Orange, Alexandria & Manassas R. R.

Change cars at the Platform opposite the Orange Depot, in Lynchburg.

This 1871 advertisement for the AM&O Railroad describes its main route and stops via Norfolk, Virginia. The railroad's main terminal was located in Lynchburg, Virginia, with daily connections from Norfolk to Baltimore, Philadelphia, and New York. The AM&O originally consisted of three divisions representing the three railroads that combined to form the AM&O. With the merger of the South Side, Norfolk and Petersburg, and Virginia and Tennessee Railroads, the AM&O was able to provide rail transportation from Bristol to Norfolk, Virginia. (VMT Inc., Archival Collections.)

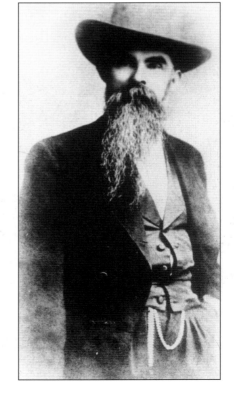

Gen. William Mahone served as the president of the AM&O Railroad for its 10-year existence. General Mahone first gained attention during the Civil War as a field commander, notorious for his unorthodox battle antics. Following the war, Mahone immersed himself in the political and business affairs of Virginia, becoming the president of the three different railroads at the same time. His energy and political savvy led the Virginia legislature to approve merging his three railroads into the AM&O. His detractors said the initials "AMO" stood for "All Mine and Otelia's," Otelia being Mahone's wife. (VMT Inc., Archival Collections.)

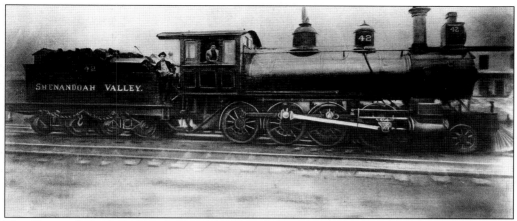

The Shenandoah Valley (SV) Railroad operated a 239-mile line from Hagerstown, Maryland to Roanoke, Virginia, which had been completed in 1883. The Norfolk & Western purchased the railroad in 1890. The SV's president, Frederick Kimball, would become one of the N&W's early and most visionary presidents. This picture of Engine 42, a Class I 2–8–0 type, was taken in 1884. (VMT Inc., Archival Collections.)

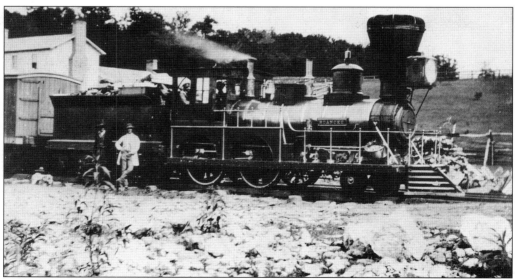

Virginia and Tennessee Railroad named rather than numbered their locomotives. Here is the locomotive *Roanoke*. Chartered in 1849 and completed in 1856, the V&T ran from Lynchburg to Bristol and was later merged into the AM&O Railroad. (VMT Inc., Archival Collections.)

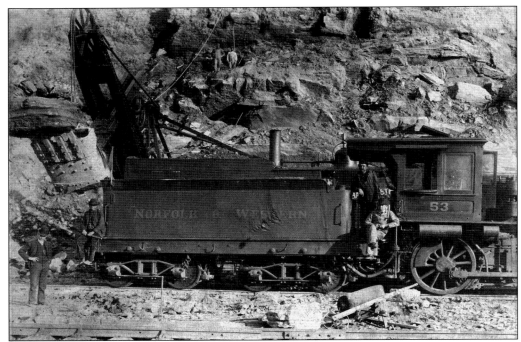

Engine No. 53 and her crew excavate for track near Bluefield, West Virginia. The N&W pioneered and financed early coal production in the mountains of West Virginia and carved the rail beds that allowed the "black gold" to move east. (VMT Inc., Archival Collections.)

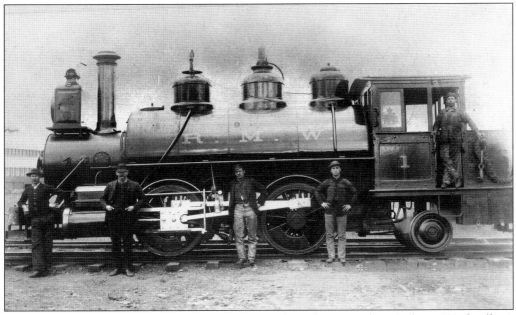

Engine No. 1 was the switching locomotive used at the Roanoke Machine Works (later Roanoke Shops) in 1886. Standing in the cab of the engine is H.S. German. Others, from left to right, are Brakemen W.H. Hall and W.W. Rule, Engineer Paul DeArmond, and Conductor Tim Patterson. (VMT Inc., Archival Collections.)

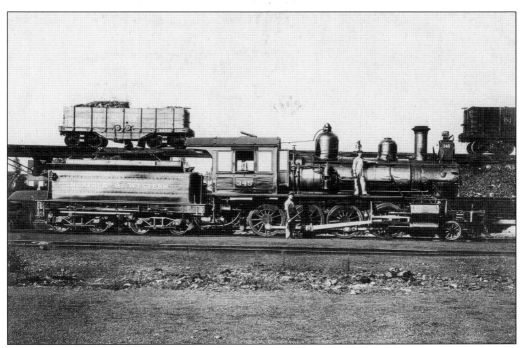

Engine No. 345 was the first compound engine owned by the N&W. This picture was made at Crewe, Virginia, in 1885. Crew members pictured are A.D. Lane, engineer, and Julian Hark, fireman. (VMT Inc., Archival Collections.)

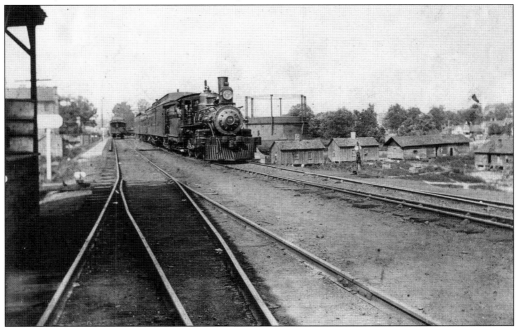

Passenger locomotive No. 29 pulls into the Winston-Salem yard in 1890. This train may have been operating on the former Roanoke and Southern track that was absorbed into the operations of the N&W in 1892. (VMT Inc., Archival Collections.)

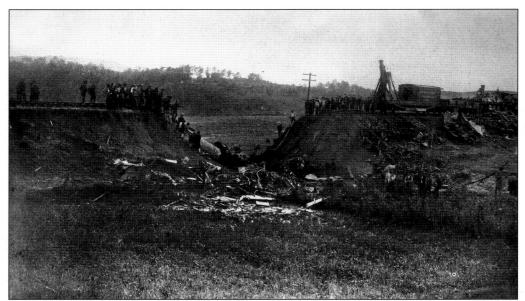

On July 2, 1889, a night storm swelled Wolf Creek (near Thaxton, Virginia), which rose out of its embankment just as passenger train No. 2 was crossing. The situation became the N&W's first major train disaster. There was only one survivor—the trainmaster, James Cassell—who was swept along by the current but managed to cling to a tree until rescued. (VMT Inc., Archival Collections.)

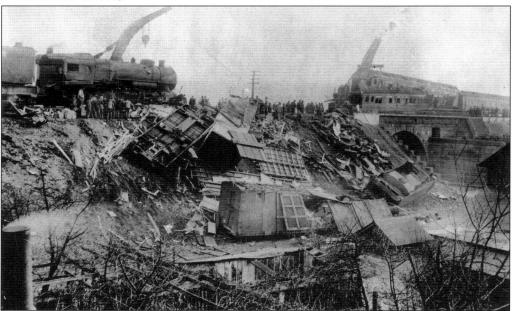

A closer view of the Thaxton wreck shows the debris pile. Engineer Pat Donovan's body was so badly mangled he was able to be identified only by his clothing. The entire woodwork of the train was burned due to exploding gas lights in the coaches. Seven cars were destroyed and six employees and eleven passengers lost their lives. Engine No. 43 is handling the wreck car. (VMT Inc., Archival Collections.)

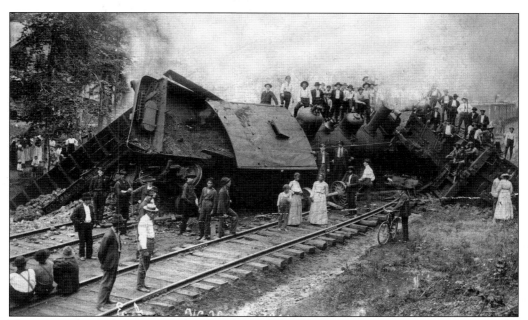

This image shows the train wreck at Powhatan, West Virginia, on August 7, 1904. Notice the double-tracking in the image. Unfortunately, the development of adequate rail safety technology was years from complete, making railroading a dangerous profession. (VMT Inc., Archival Collections.)

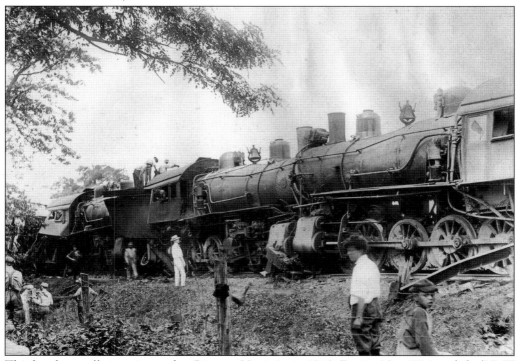

This head-on collision occurred at Rippon, Virginia, in 1918. Engine No. 481 is at left. (VMT Inc., Archival Collections.)

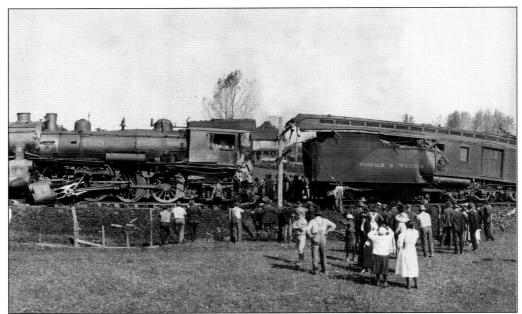

On October 20, 1920, Trains No. 14 and No. 37 collided at Rural Retreat, Virginia. Note the collapsed front half of the first baggage coach. While engines could often withstand collisions, the wood-constructed baggage and passenger coaches were extremely vulnerable. (VMT Inc., Archival Collections.)

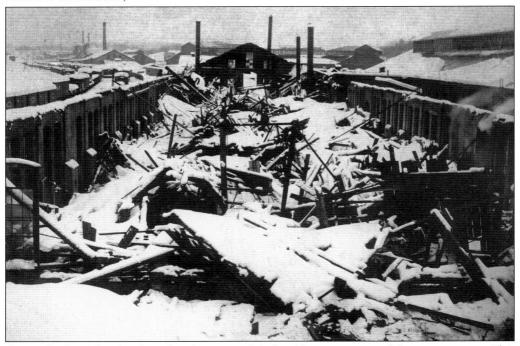

Given the hazards of early railroading, even Mother Nature at times did not cooperate. This image shows a collapsed car shop in Roanoke due to a heavy snowstorm in 1890. (VMT Inc., Archival Collections.)

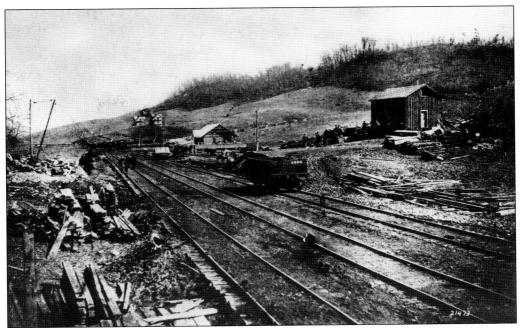

This is a photograph of the Bluefield Yard in 1888. In that year the N&W organized into four operating divisions with divisional points at Crewe, Radford, Roanoke, and Bluefield. Each division had equal miles. Prior to this, there had been the Eastern and Western Divisions with the divisional point of separation being Lynchburg. (VMT Inc., Archival Collections.)

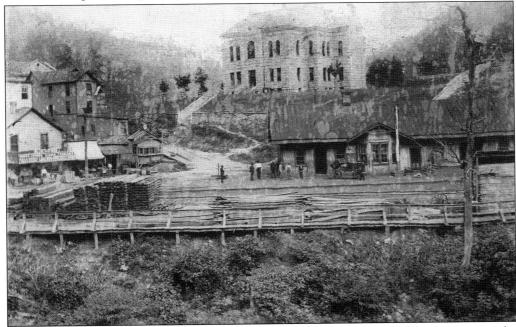

This image shows Welch, West Virginia, around 1905. The old N&W station is in the foreground; the courthouse is in the background and businesses are pictured at left. (VMT Inc., Archival Collections.)

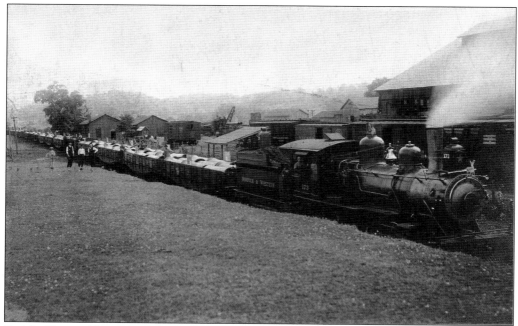

Freight Engine No. 173 of the Radford Yard is depicted at a Radford pipe shop around 1900. (VMT Inc., Archival Collections.)

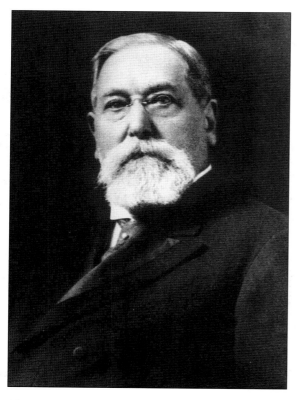

Henry Fink, president of the N&W from 1895 until 1902, was the chief operating officer for Mahone's AM&O Railroad. A life-long bachelor, Fink had immigrated to the United States with his brother in 1851 and became a railroad engineer four years later. While N&W president, Fink often directed the railway's activities from his New York office. Though providing the N&W steady leadership, Fink made one significant error in judgment: he saw little future in coal. During a visit to the Norfolk division in 1895, his superintendents pleaded for him to approve sidings and storage tracks for more coal traffic. Fink reportedly replied, "What would we do with coal when we got it down here? No one will buy it. And none of us can eat it. Wait awhile." (VMT Inc., Archival Collections.)

Two
WORKING ON THE
RAILROAD

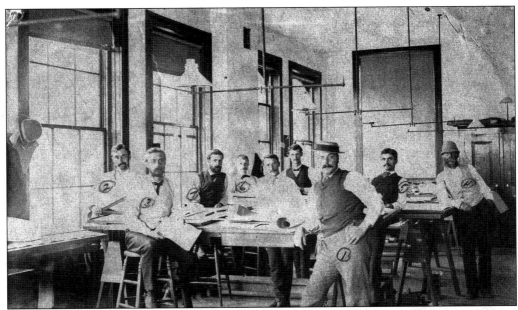

The drawing room employees in the N&W office building in Roanoke are photographed in 1888. Pictured from left to right are John Worthington, Charles Jacobsen, James Woods, Fred Scuiffer, two unidentified people, George Worthington, Otis Bellingrodh, and Servelius Bisphan. (VMT Inc., Archival Collections.)

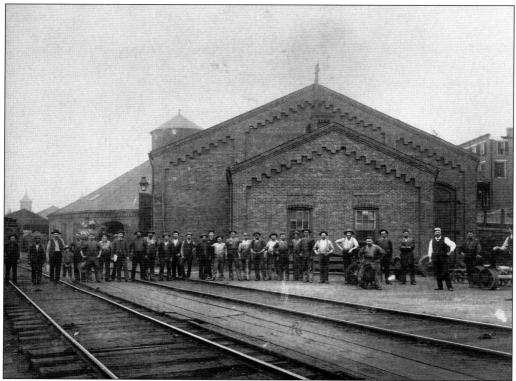

Employees at the N&W roundhouse in Lynchburg, Virginia, posed for this photograph in 1887. While Lynchburg served as the divisional point for the N&W during its first few years, increased coal and ore traffic caused the N&W to move its divisional points further west in 1888. (VMT Inc., Archival Collections.)

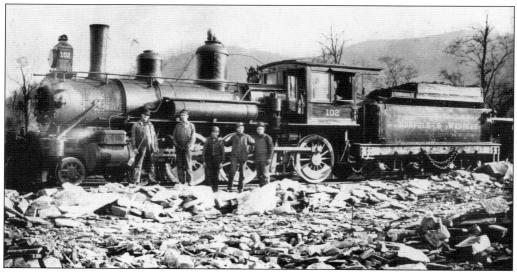

The crew of Engine No. 102, shortly after the engine was taken over by the N&W, included Conductor Lawrence Boyles, Engineer George Agee, Fireman Harley Pugh, and Brakemen Jesse Honaker and R.C. Warden. (VMT Inc., Archival Collections.)

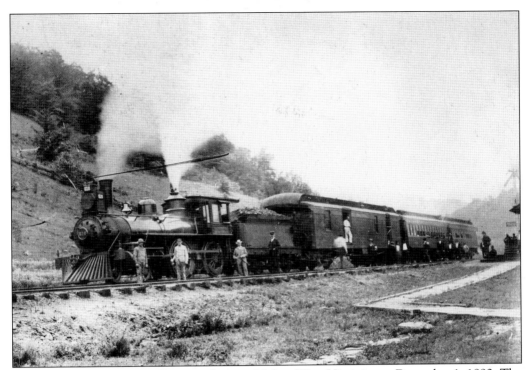

Class Q Engine No. 516 pulls into a depot at Nolan, West Virginia, on December 1, 1892. The engine was originally put into service in April of 1882. Crew members are servicing both passenger and express cars. (VMT Inc., Archival Collections.)

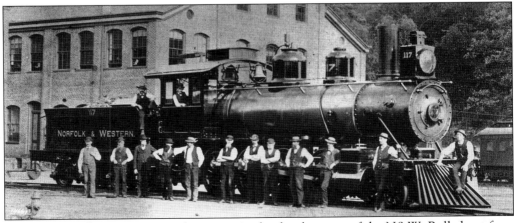

This photograph captures a proud moment in the development of the N&W. Rolled out from the shop is the first locomotive built by the Roanoke Machine Works in September of 1884. RMW would later become the N&W's Roanoke Shops. The engine is a Class I. (VMT Inc., Archival Collections.)

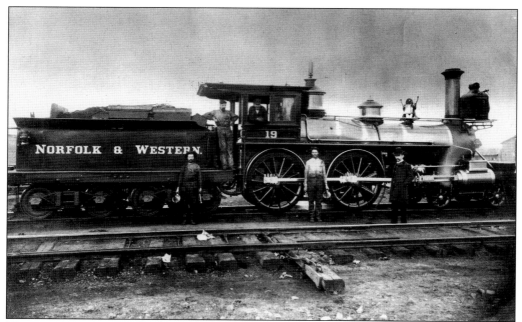

The crew of Engine No. 19 is seen in this image from 1885. This engine, like most of the engines used by the N&W in its infancy, was built by the Baldwin Locomotive Works. (VMT Inc., Archival Collections.)

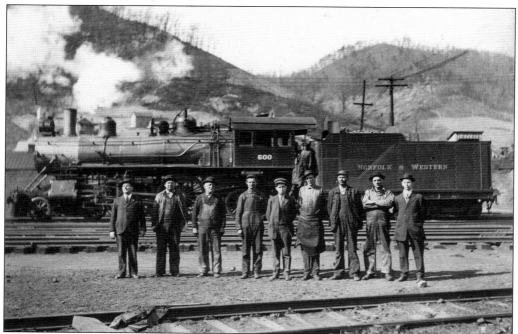

The shop gang of the Portsmouth (Ohio) Shop pose in front of Engine No. 600. The N&W in 1901 purchased the former Cincinnati, Portsmouth, and Virginia Railroad for $2.5 million. Portsmouth would become a major point in the future operations of the N&W. (VMT Inc., Archival Collections.)

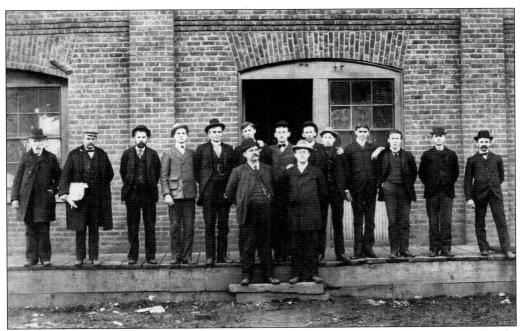

One of the N&W's largest freight stations was at Roanoke, Virginia. Here are the freight station employees of 1901. The average annual wage for a railroad worker in America at the turn of the century was $740, much higher than the average American wage. (VMT Inc., Archival Collections.)

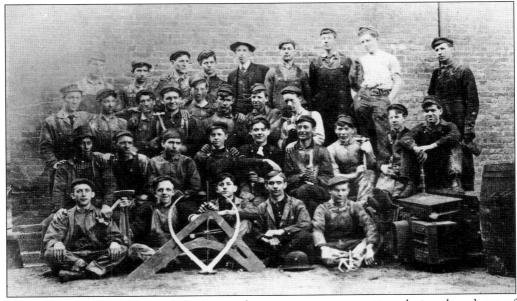

The railroad employed a number of young boys to serve as apprentices during the advent of child labor laws. This photograph shows the Roanoke Shops machinist apprentices in 1907. A young apprentice would work a 10-hour day and would often work for overtime on weekends and Sundays. The apprenticeships often opened doors of opportunity for later railroad employment and/or college admissions. (VMT Inc., Archival Collections.)

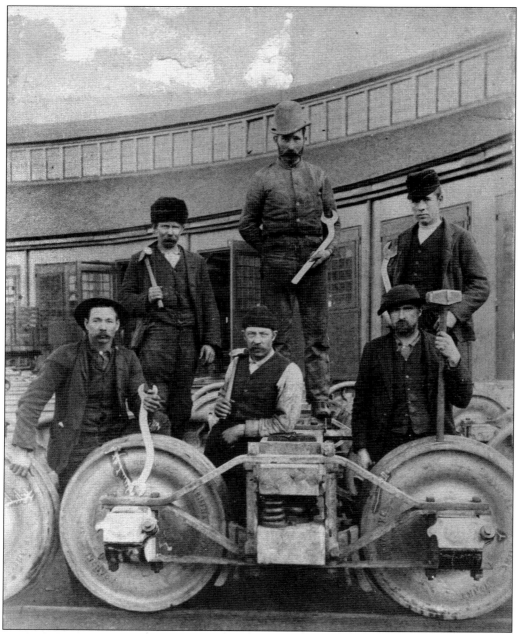

Some employees at the Roanoke roundhouse posed for this picture *c.* 1910. Notice the various tools each is holding which display the different types of work done at the roundhouse. The men are posing with locomotive wheels. (VMT Inc., Archival Collections.)

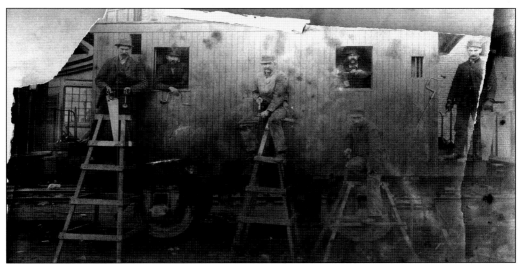

This old photograph, taken in 1888, shows employees of the Roanoke Machine Works building a caboose. Those in the picture are, from left to right, W.E. Meadows, Ted Swain, William Patterson, R.L. Daddow, R.L. Funk, and T.S. Jones. (VMT Inc., Archival Collections.)

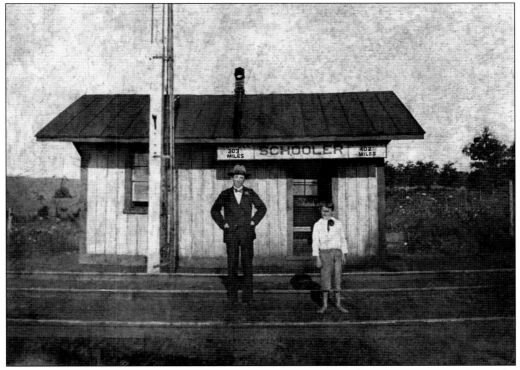

The station at Schooler, Virginia, was operated by W.H. Cord (left). The picture shows the station in July 1900, a few months before it was closed. The small station operated from March 1883, when coal first began to move from Pocahontas to Norfolk, until 1900 when the station was bypassed by new track. The young man in the photograph is W.H. Kegley. (VMT Inc., Archival Collections.)

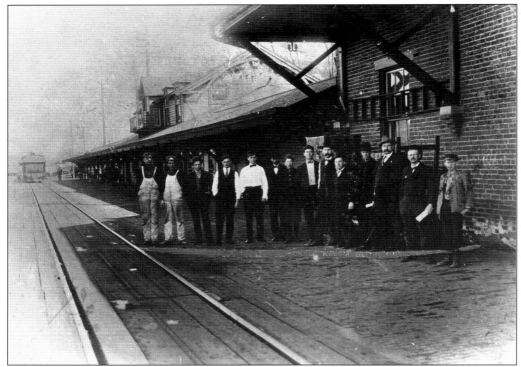

Here is the old Yard Office located upstairs from the N&W Passenger Station at Radford, Virginia, as it appeared in 1916. Pictured from left to right are Zince, Stump, E.E. Allen, Lawrence Allen, Louis Lucas, Horace Price, Tom Heslep, H.A. Hall, J.C. Turner, O.C. Charlton, J.H. Barnett, T.D. Gravah, Tebe Lawrence, Arthur Roberto, and Kuhn Barnett. (VMT Inc., Archival Collections.)

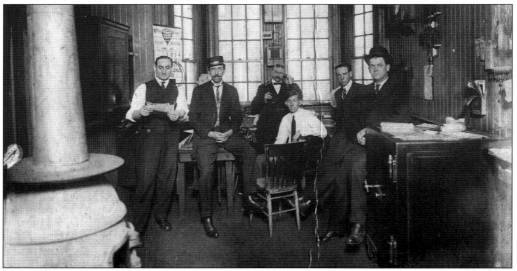

This is a station office, location unidentified, in 1914. The men pictured inside the office are C.E. Moore, C.C. McPherson, W.L. Bingham, Harvey Call, and W.G. Light. (VMT Inc., Archival Collections.)

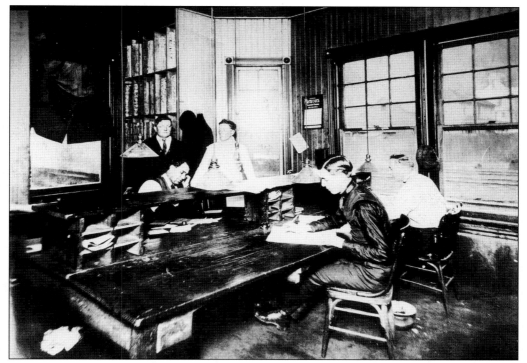

This was the old car record office at Portsmouth in 1914. Appearing in the picture from left to right are Floyd Chabot (seated), Paul Jones, S.A. Highfield, H.H. Hester, and John Farley. (VMT Inc., Archival Collections.)

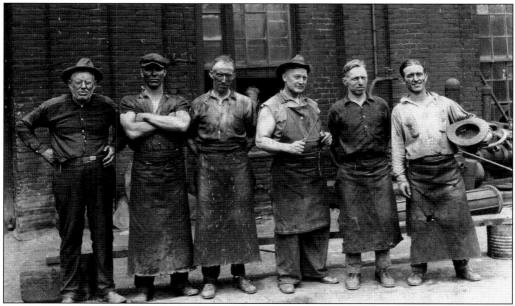

The blacksmith gang at the Bluefield, West Virginia, Shops in 1927. Notice the thick, muscular arms on these men. Blacksmithing was rugged and often dangerous work but a necessary trade among many to make the railroad operate. (VMT Inc., Archival Collections.)

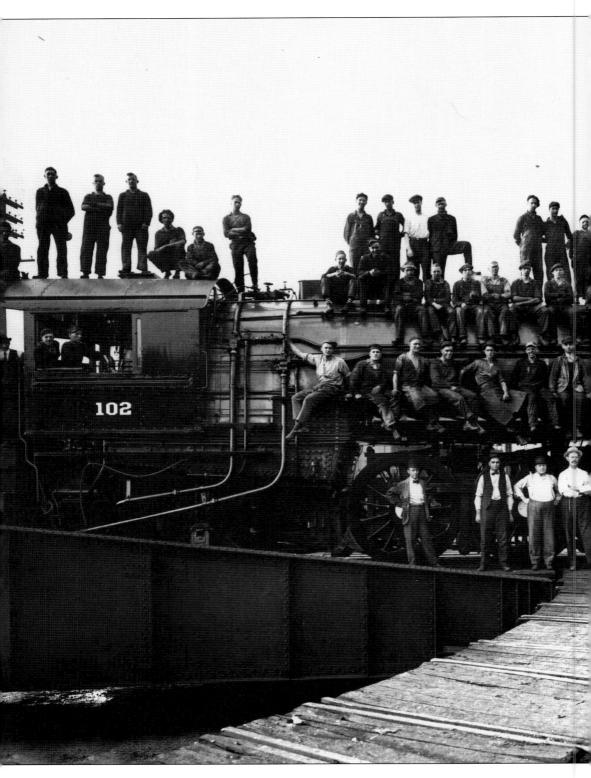

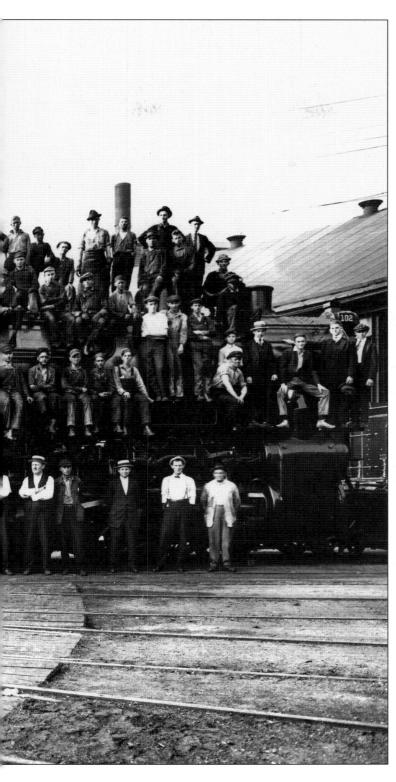

Engine No. 102 rolls proudly out of assembly at the Roanoke Shops and the men of the shop pose for the customary photograph of the new engine. This picture was taken in 1917, a year when the N&W had nearly 970 engines in operation. (VMT Inc., Archival Collections.)

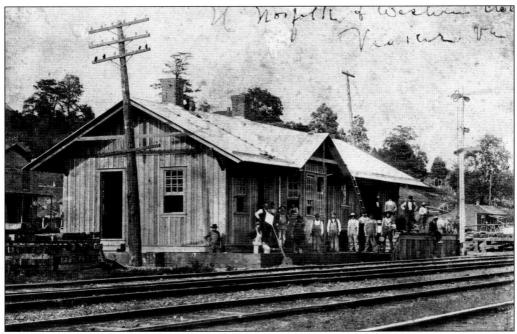

The carpenter crew has almost completed work on the station at Vicker, Virginia, when this photograph was taken. Carpenters built everything from depots to boxcars, and cabooses to the finished interiors of passenger coaches. (VMT Inc., Archival Collections.)

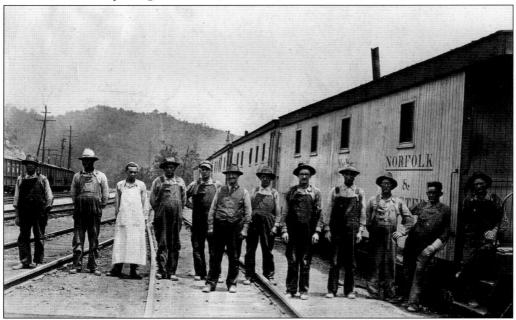

The 1928 Carpenter Force No. 1, Pocahontas Division, at Richlands, Virginia, included (from left to right) R.L. Sorah, J.A. Dye, Dayton Henderson, O.J. Lawson, R.L. Maxwell, J.D. Farmer, T.R. Stinson, S.T. Sparks, G.W. Petts, E.W. Clay, A.G. Quillen, and R.H. Honaker. Notice the "camp cars" behind them where the men ate and slept. (VMT Inc., Archival Collections.)

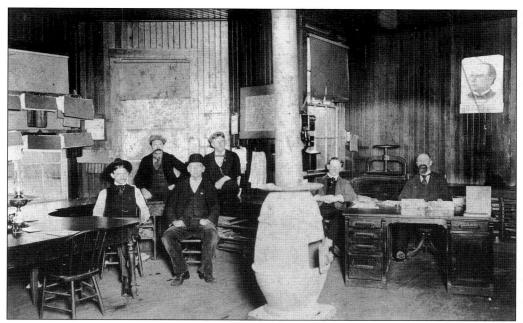

The Portsmouth Freight Office of 1899 included (from left to right) L.M. Doty, Gus Kehrer, Fred Dressler, S.R. Crawford, T.M. O'Connor, and Theodore Doty. (VMT Inc., Archival Collections.)

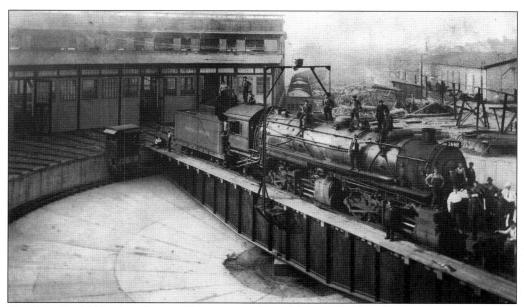

On July 3, 1919, the first mallet engine, No. 1442, was placed on the new 115-foot turntable and in the new roundhouse of the Shenandoah Division. For this moment, the men of the roundhouse take a break to pose in recognition of the achievement. (VMT Inc., Archival Collections.)

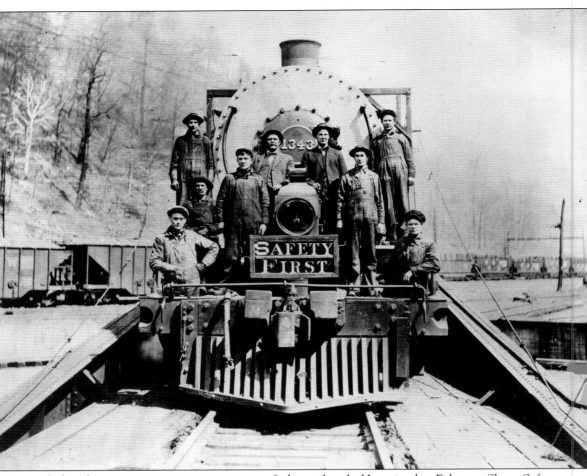

Safety became a paramount concern of the railroad. Here is the Eckman Shop Safety Committee on Engine No. 1343. In 1893, Congress passed the Railroad Safety Appliance Act, and, in 1916, rail employees won Congressional approval for an 8-hour work day, as opposed to 10. (VMT Inc., Archival Collections.)

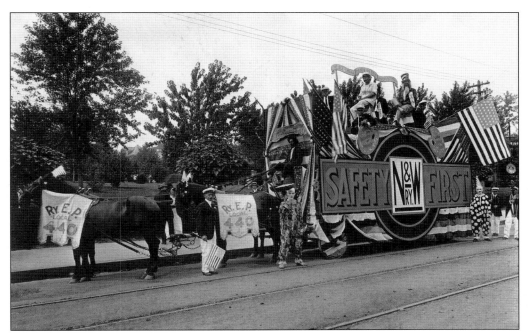

One of the unions, Local 440, entered this "Safety First" float in a Roanoke parade. Although undated, its does testify to the cooperation by rail unions and officials to improve worker safety. (VMT Inc., Archival Collections.)

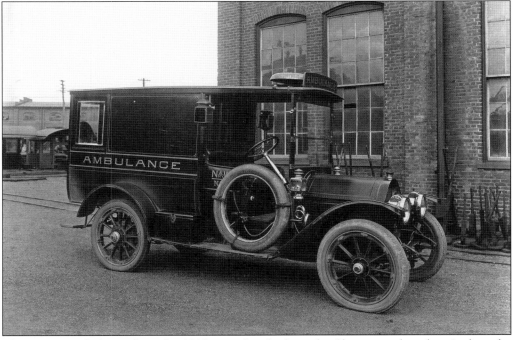

This N&W ambulance from the 1920s signifies the hazards of being a rail worker. In fact, the N&W financed the hospital in Roanoke for its first two years of operation so rail families could get necessary medical services. (VMT Inc., Archival Collections.)

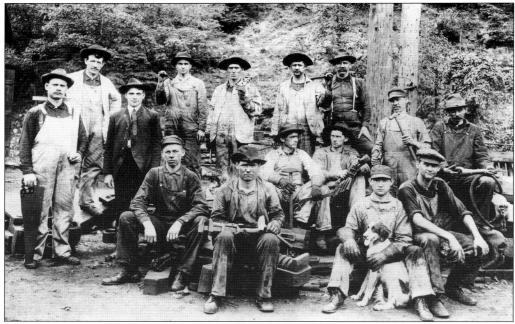

A picture of car yardmen at Kimball, West Virginia, in 1906 shows the employees and their tools. As the coal mines opened, the number of men employed by the N&W soared, bringing economic opportunity to many West Virginia families. (VMT Inc., Archival Collections.)

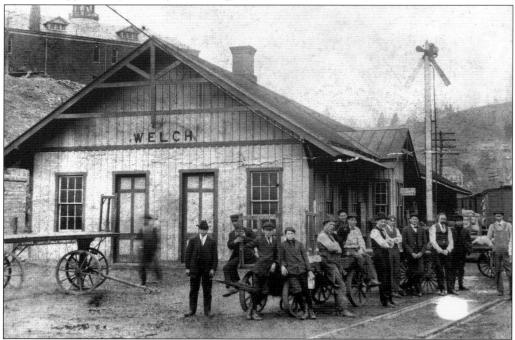

This photograph captures the station and crew at Welch, West Virginia, c. 1900. It is believed that the building in the background is the courthouse. Notice the freight cart to the left. (VMT Inc., Archival Collections.)

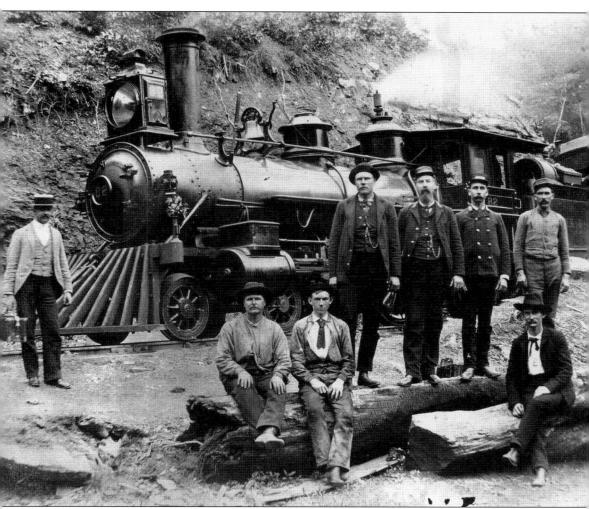

This photograph of the crew of Engine No. 82 was taken in 1888, when Goodwill, West Virginia, was a western terminus. The engine was standing on the Wye track. Crew members are S.D. Clowers, engineer; R.S. Brown, engineer; James Emmons, fireman; George Thomas, conductor; James Price, brakeman; and Essie Shell, baggage master. (VMT Inc., Archival Collections.)

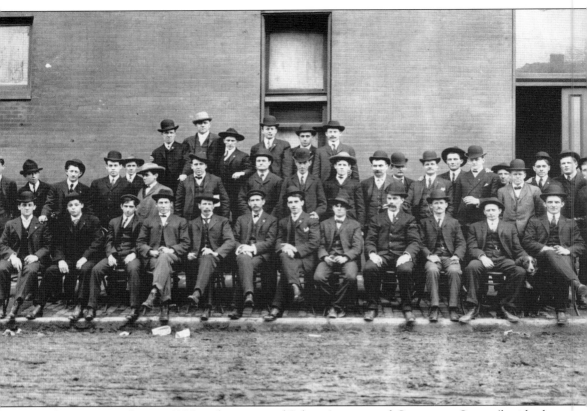

This picture, taken in 1905 at the corner of Salem Avenue and Commerce Street (beside the building then known as the Salvation Army House), shows Roanoke Boiler Shop employees. Pictured from left to right are (front row) Frank Bianchi, T.D. Equi, John Griffin, P.E. Lawhorn, F.H. Wigmore, George Leisinger, T.J. Muray, James Conway, Edward Irvin, Louis Litsinger, Oren Ruefly and his Irish Setter, and F.F. Feterman; (middle row) Mike Fitzgerald, J.L. McDonald, E.S. Kaetzel, Thomas Dugan, William Hough, Pete Conway, Edgar Davis, J.T. Withers, John Smith, B.I. Wade, W.E. Drabble, G.H. Hann, W.F. Dupree, W.D. Cassidy, E.F. Horgan, W.G. Hardy, F.L. Zeone, F. L. Pitzer, W.A. Kimmerling, and Ed Roderick; (back row) H.H. Lawhorn, Paul Wiegand, L.L. Hough, C.G. Fridinger, J.F. Horton, and Ike Neff. (VMT Inc., Archival Collections.)

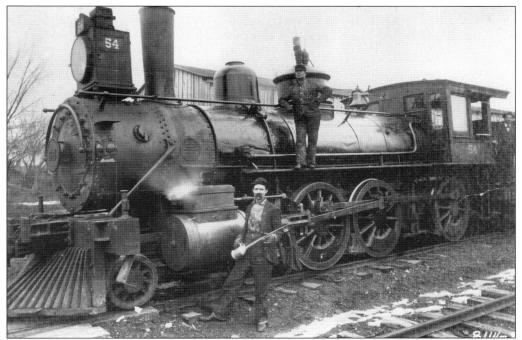

Engine No. 54 is shown here about 1900 with her crew of (from left to right) Engineer E.H. Jones, Fireman Guy Emery, and Conductor Lloyd Pugh. The train was running between Sardinia and Hillsboro branch, and the main line of the Cincinnati, Portsmouth, and Virginia Railroad. (VMT Inc., Archival Collections.)

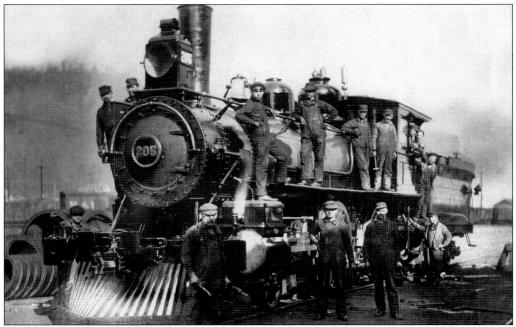

This photograph is of the shop employees and crew of Engine No. 205 taken in 1926 in Roanoke, shortly after the locomotive's construction. (VMT Inc., Archival Collections.)

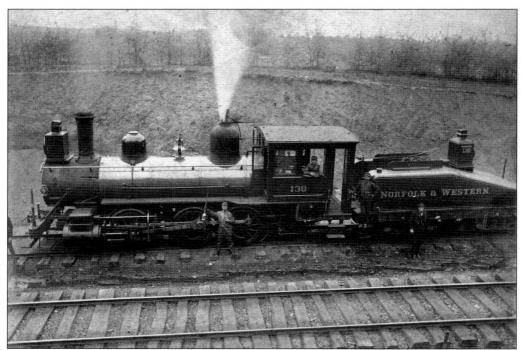

This picture was taken at East Radford coal wharf on July 4, 1887. It depicts Engine No. 138 and crew. Mr. Akers, engineer; Charle Roby, fireman; and Mr. Allen and Mr. Adkins, brakemen, are shown. (VMT Inc., Archival Collections.)

Engine No. 17 is surrounded by rail employees in this photograph taken near Elkhorn, West Virginia, c. 1892. On the ground at the extreme left is G.W. Pile; standing fourth from the left is H.S. Walker; standing second from the right is C.C. Edmondson; and R.H. Miller is standing on the pilot. All others are unidentified. (VMT Inc., Archival Collections.)

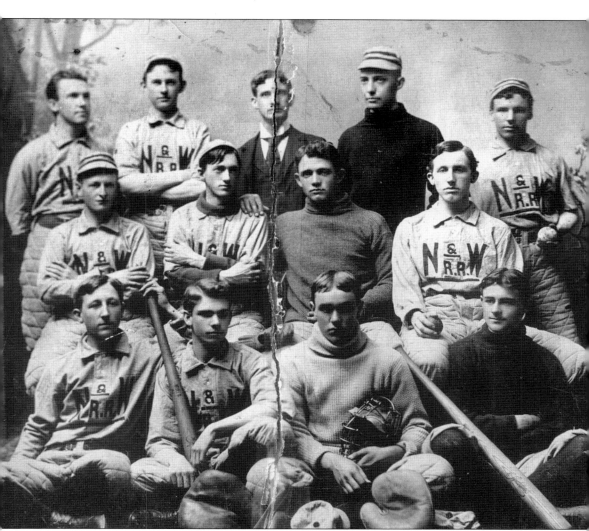

Being with the railroad was not always just about work. Here is the N&W General Office Building Baseball Team from 1895. Team members included the following, from left to right: (front row) ? Coleman, Winfree Reed, Max Howe, and G.F. Butler; (middle row) Harry Moore, Garnet Junkin, George Bentley, and Dupuy Coleman; (back row) "Tate" Greer, Bob Ott, Julian Barksdale (manager), Arthur Woodson, and unidentified. The railroad sponsored baseball teams, bowling leagues, and even employee tennis tournaments during its history. (VMT Inc., Archival Collections.)

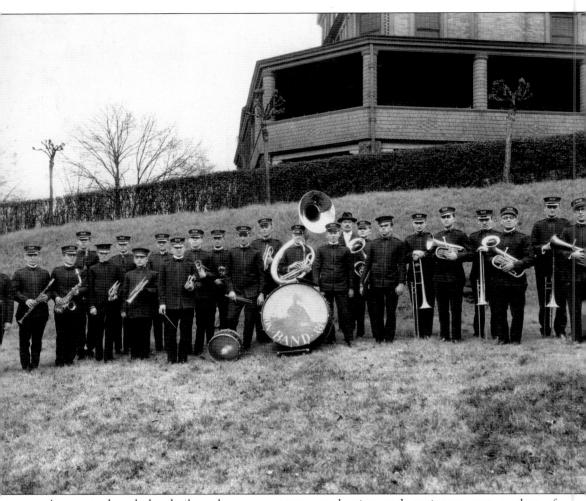

Amongst the clerks, boilermakers, carpenters, mechanics, and engineers were a slew of instrumentalists, singers, song writers, and composers. Together, they formed the Roanoke Shop Band. Here the band stands on the grounds of the Hotel Roanoke on January 11, 1924. Members of the band were responsible for composing the music for "Tech Triumph," which was adopted by the Cadet Corps of VPI as their victory song. So plentiful was the music talent amongst the N&W employees that each division could organize its own band for special events and local parades. (VMT Inc., Archival Collections.)

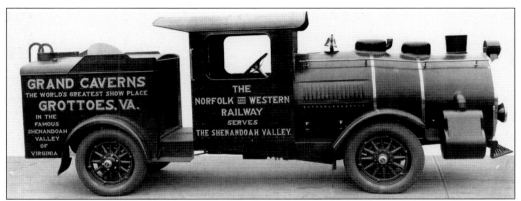

Public relations was not always left to copy editors and high-ranking N&W officials. This image shows a "train" built by the men in the Roanoke Shops in 1927 for advertising purposes. Note the truck's hood mimics the look of a locomotive. (VMT Inc., Archival Collections.)

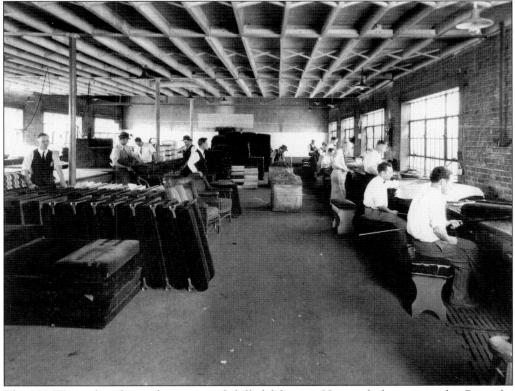

The N&W employed a wide variety of skilled laborers. Here upholsterers in the Roanoke Shops in 1928 prepare seats for the passenger coaches. In addition to outfitting trains, the upholstery shop also fitted office furniture and some items for the Hotel Roanoke. (VMT Inc., Archival Collections.)

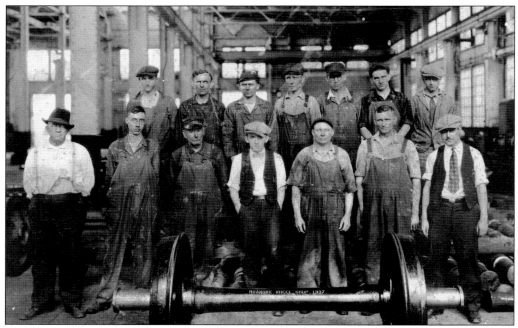

"Roanoke Wheel Shop 1927" is stamped upon the new car wheels proudly displayed by the men of the wheel shop in this photograph. (VMT Inc., Archival Collections.)

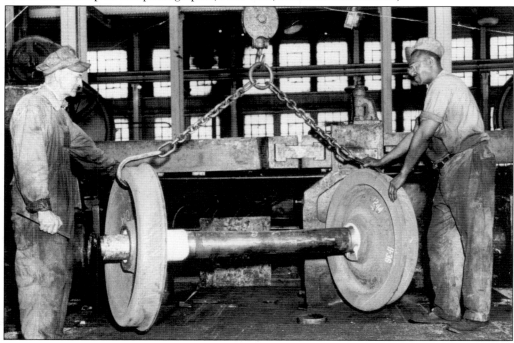

Two employees examine car wheels at the Roanoke Shops in this picture from the late 1940s. C.G. Wiley is the man on the right. Unfortunately, African-American employees of the N&W could not be promoted beyond entry-level positions until the passage of the Civil Rights Act of 1964 made discrimination illegal. (VMT Inc., Archival Collections.)

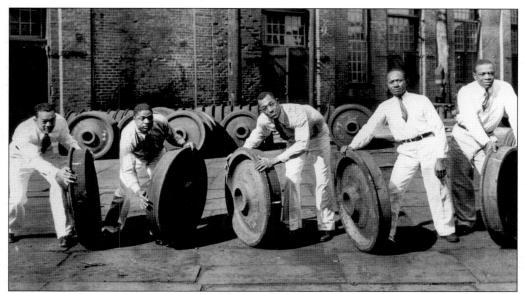

The "Wheel Rollers" of the Roanoke Shops shown here in the late 1930s include (from left to right) Earl Dunning, John Canty, Charles Wiley, Monk Wiggins, and Thomas Campbell. The N&W Wheel Rollers competed in wheel rolling competitions around the nation and always placed high. (VMT Inc., Archival Collections.)

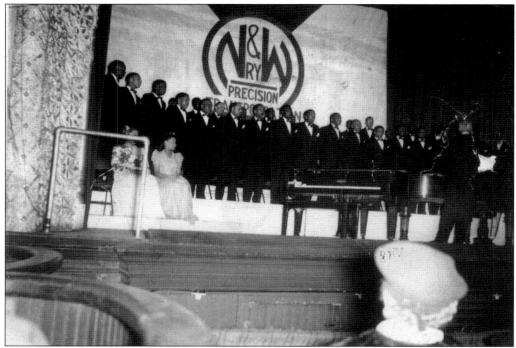

The N&W Male Chorus consisted of African-American employees who toured and performed hundreds of concerts. This image shows the Chorus in a performance at Roanoke's Academy of Music c. 1950. The Chorus was of such high caliber that one needed an audition to join. (VMT Inc., Archival Collections.)

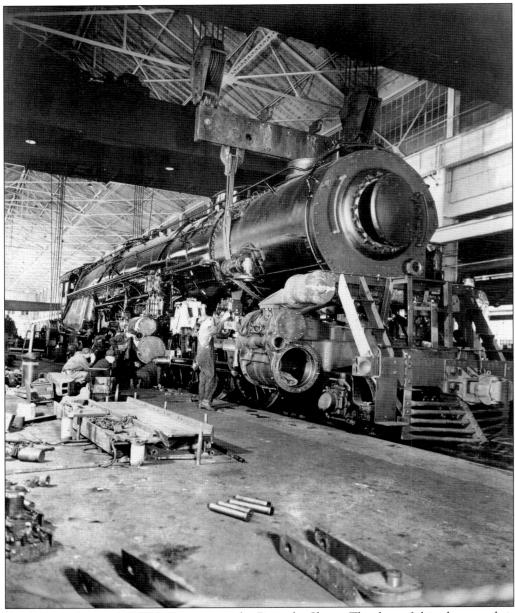

Employees repair an N&W locomotive at the Roanoke Shops. The date of this photograph is unknown. (VMT Inc., Archival Collections.)

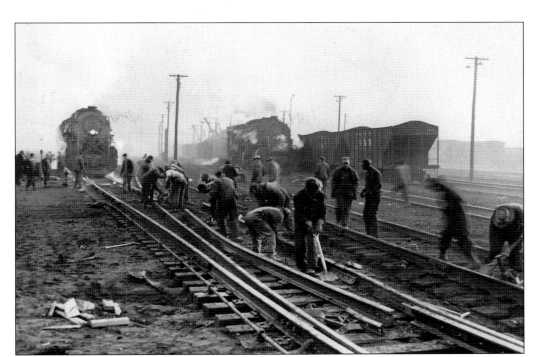

This picture show track crews at work along the N&W line. Track laying and maintenance was an awesome undertaking, given the thousands of miles of track owned and operated by the N&W. Only in the middle part of the 20th century did track work become more mechanized. (VMT Inc., Archival Collections.)

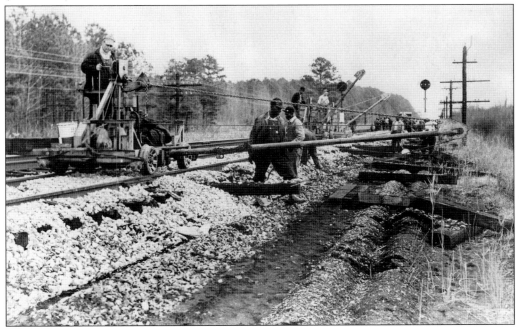

Here is but one example of how mechanization assisted significantly in the maintenance of tracks. A machine removes cross ties for the crew. (VMT Inc., Archival Collections.)

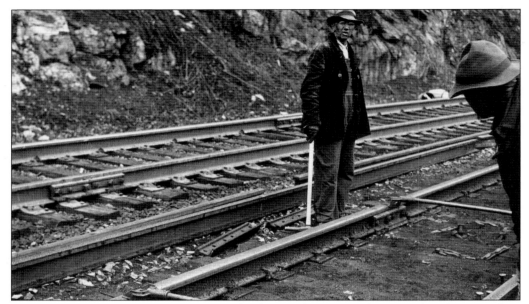

A foreman gauges track to make certain the distance between rails is exactly 4 feet, 8 inches. In 1883, the N&W operated primarily on a 5-foot gauge. However, on June 1, 1886, the N&W, along with other Southern railroads, adopted the now-standard gauge of 4 feet, 8 1/2 inches. At daybreak on June 1, the N&W ceased all freight and passenger train operations, and labor gangs began re-spiking the rails, usually moving the south rail. By early afternoon the job was complete. It is estimated that the N&W, along with other Southern railroads, changed 11,000 miles of track that day. One N&W historian noted this was the single greatest one-day change ever to occur in the history of the railroad. (VMT, Inc., Archival Collections.)

The employees of the Roanoke, Virginia, freight office obviously put on their best for this picture taken in June 1924. (VMT Inc., Archival Collections.)

Three
THE IRON HORSES

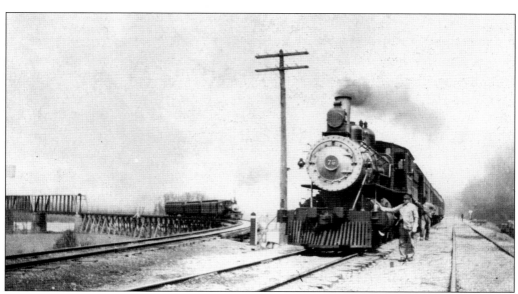

Engine No. 76 was a Class U engine. On the N&W line these engines numbered 71 through 85. This photograph was taken in 1892. (VMT, Inc., Archival Collections.)

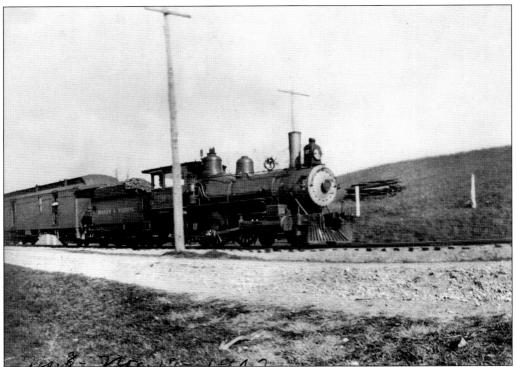

Engine No. 37 was a Class N, as were all engines numbered 28 through 37. These engines, purchased by the N&W, were made between 1887 and 1888. This photograph was taken at Wakefield, Ohio. (VMT, Inc., Archival Collections.)

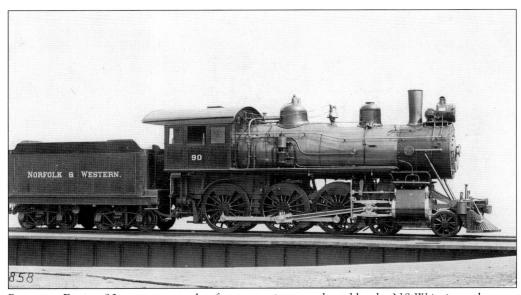

Passenger Engine 90 was an example of many engines purchased by the N&W in its early years from the Baldwin Locomotive Works. Engine 90 was a Class A engine as were engines 86 to 90. These were made by BLW between 1902 and 1904. (VMT, Inc., Archival Collections.)

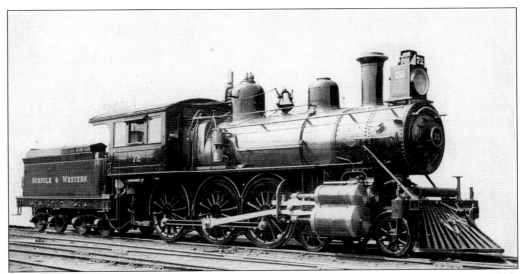

Engine 72 is another example of the Class U locomotive built by Baldwin Locomotive in 1892. The passenger locomotive weighed in excess of 132,000 pounds and was later converted to simple cylinders. (VMT, Inc., Archival Collections.)

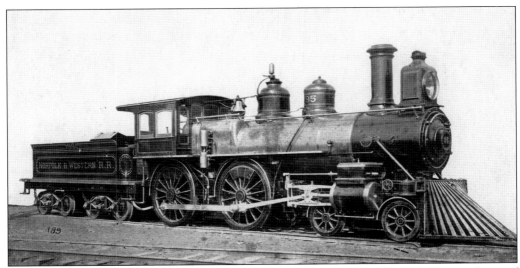

The old Class M engine was built by Baldwin Locomotive in 1883. The N&W owned two of these engines, Numbers 94 and 95, as shown above. (VMT, Inc., Archival Collections.)

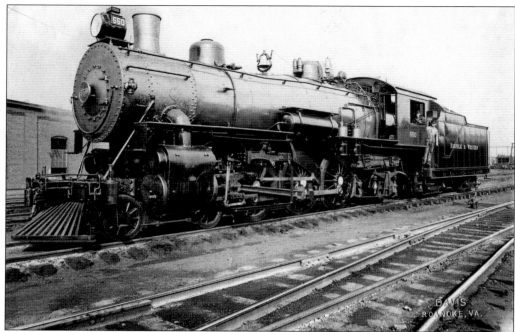

Engine 550 is a later example of the steam locomotive used by the N&W as compared to the surrounding images. Here the crew poses for a picture by George Davis taken at Roanoke, Virginia, c. 1918. (VMT Inc., Archival Collections.)

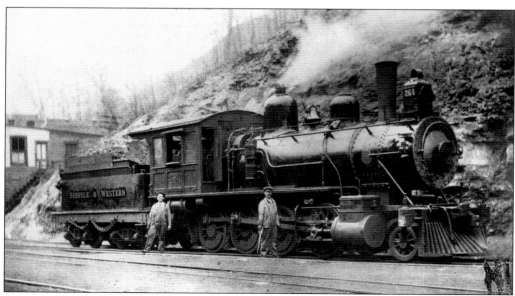

An early example of freight locomotives used by the N&W was Engine No. 264. Its weight was 120,565 pounds and was in use at the time of this photograph (1891). (VMT, Inc., Archival Collections.)

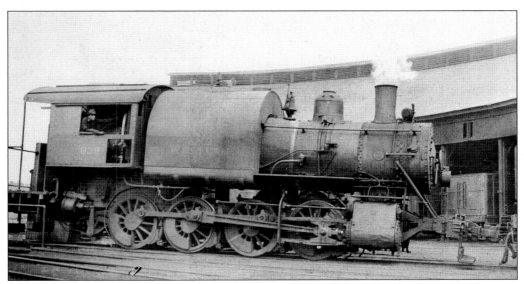

This engine was a Class W-1, 2–8–0 type and was originally built by the Roanoke Shops in October 1900. The above photograph was taken at Roanoke on June 17, 1925. (VMT Inc., Archival Collections.)

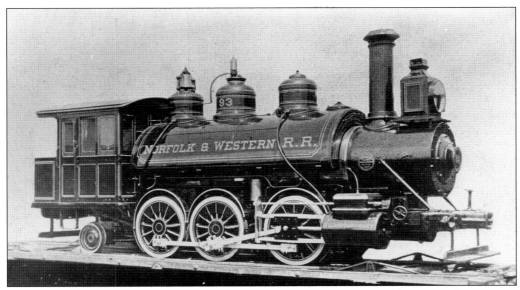

This small shifting engine, No. 93, was used at Roanoke Machine Works. It was built by Baldwin Locomotive Works in 1883 and weighed only 81,000 pounds. (VMT Inc., Archival Collections.)

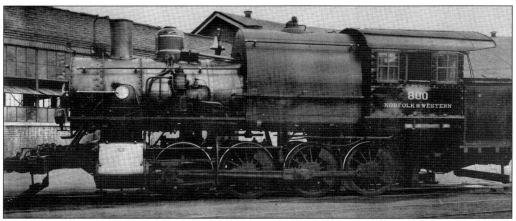

Engine 800 was an N&W Class W6. These engines, numbered 800 through 814, were made between 1898 and 1899. (VMT Inc., Archival Collections.)

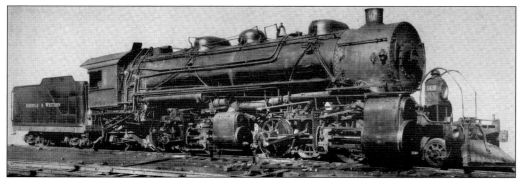

Engine No. 1438 was built in 1916 and was an N&W Z1L. This class of engine was made between 1912 and 1918 and proved especially helpful in mountain regions. Note the old-style headlamp in the photograph. (VMT Inc., Archival Collections.)

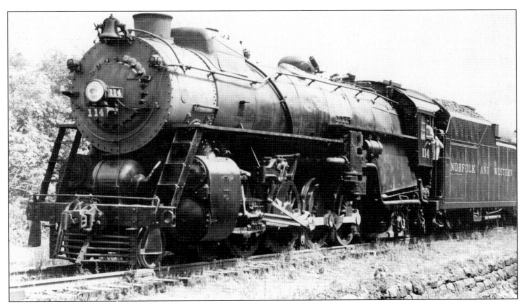

Engine No. 114 was a member of the K-1 Class of N&W locomotives. This class of engine, numbering 100 to 115, was built between 1916 and 1917. The Class K engines were built to pull more weight since new steel passenger cars were replacing those made earlier from wood. (VMT Inc., Archival Collections.)

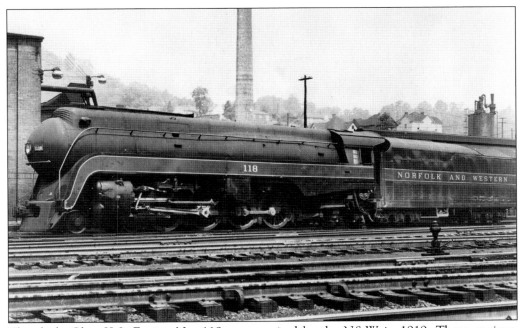

The sleek, Class K-2, Engine No. 118 was acquired by the N&W in 1919. These engines, numbering 116 through 125, were rebuilt later and streamlined by the N&W. (VMT Inc., Archival Collections.)

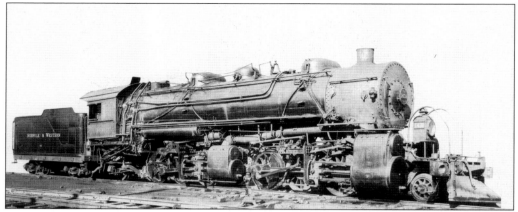

Engine No. 1438 was one of many Class Z1A engines used by the N&W. This particular engine was built in January 1916 in Schenectady, New York. These engines (Nos. 1315 through 1438) were built between 1912 and 1917. A number of them were purchased at that time to enhance N&W's ability to keep up with its rapidly expanding business. (VMT Inc., Archival Collections.)

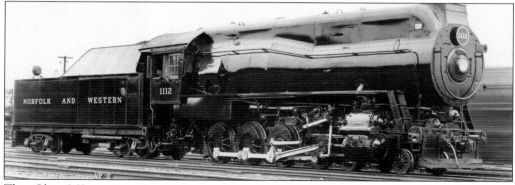

This Class M2 engine, No. 1112, was built in 1910. Their purchase was almost solely in response to the increased demands for hauling coal. (VMT Inc., Archival Collections.)

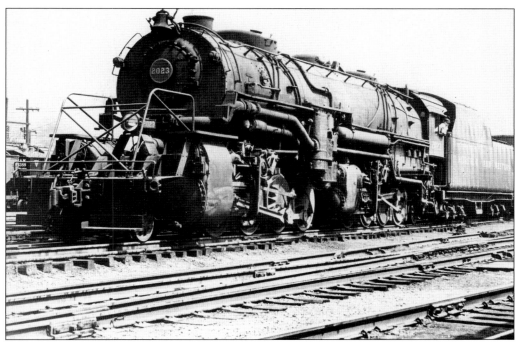

Engine No. 2023 is a Class Y3 locomotive. This was one of 50 such engines built between 1919 and 1923. (VMT Inc., Archival Collections.)

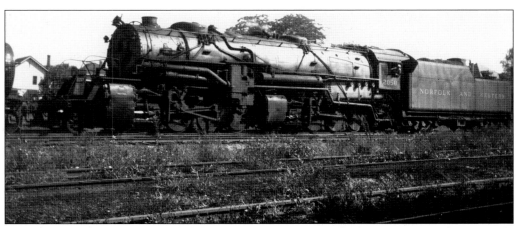

The Class Y3A engines included locomotive No. 2058. These engines, numbering 2050 through 2079, were built in 1923. This photograph was taken in Cincinnati in 1945. (VMT Inc., Archival Collections.)

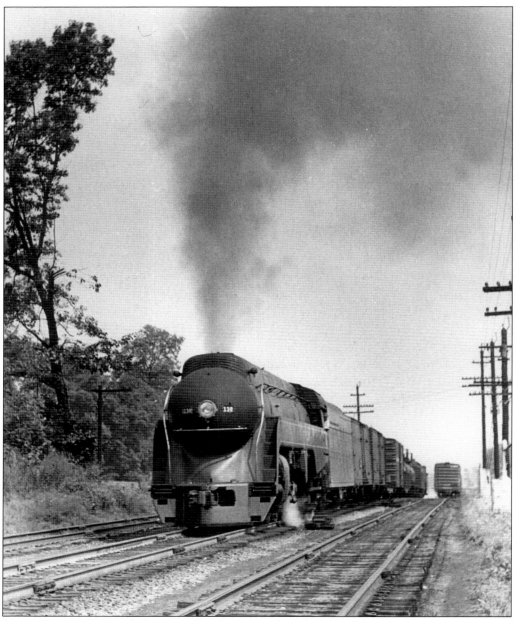

Steam Engine No. 130 (Class K-2A) is shown on the job. (VMT Inc., Archival Collections.)

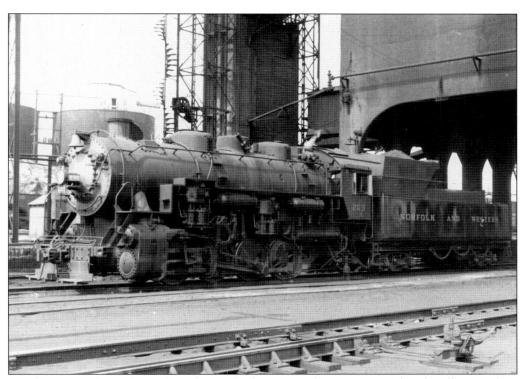

Number 209 is shown here when she was built in 1926. (VMT Inc., Archival Collections.)

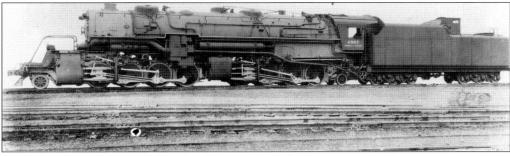

The Class Y-4 engines were developed by the N&W in 1927. Only 10 of these were produced, with Engine No. 2087 among them. (VMT Inc., Archival Collections.)

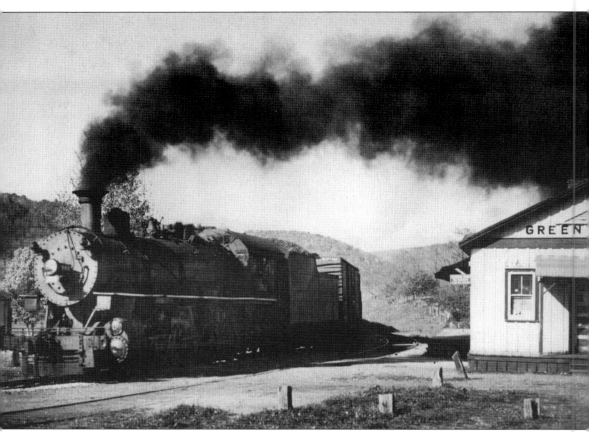

Engine No. 382 runs the steepest grade of all—a sustained three percent grade to the summit at White Top Station. This run, affectionately known as the "Virginia Creeper," ran between Abingdon, Virginia, and West Jefferson, North Carolina. In this photograph the Class M engine passes Green Cove depot but is still three rail miles from the summit. (VMT Inc., Archival Collections.)

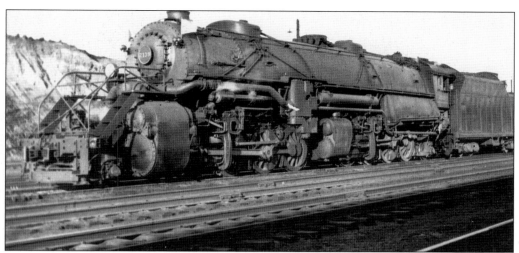

In an effort to deal with heavier freight times, the N&W developed the Y-6 locomotive. While retaining many of the design elements of previous Y engines, the Y-6 had a new steel frame, roller bearings, and mechanical lubrication at 213 points. A peak horsepower of 5,500 was achieved at 25 mph. Pictured here is Engine No. 2139 at Roanoke in 1939. The Y-6s were made between 1936 and 1940. (VMT Inc., Archival Collections.)

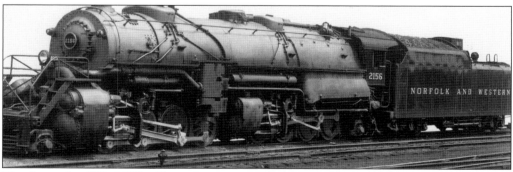

The demands of World War II were heavy upon all railroads. To deal with increased traffic, the Class Y6 was developed in 1942, such as Engine No. 2156. (VMT Inc., Archival Collections.)

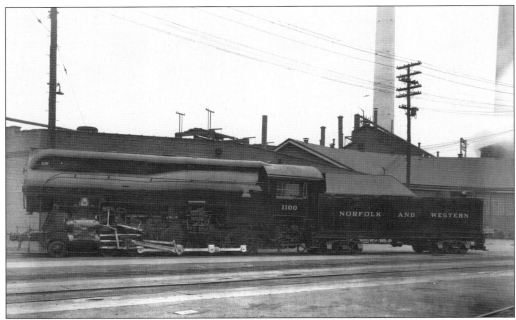

Engine No. 1100, a Class M2, was one of a number of engines purchased by the N&W in 1910. The M-Class engine as rebuilt had a 4–8–0 wheel alignment allowing it to meet the freight demands of the railroad. (VMT Inc., Archival Collections.)

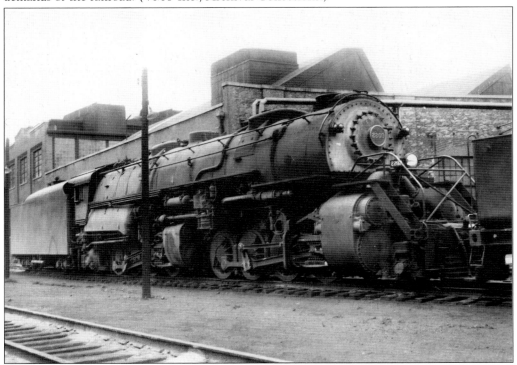

Between 1948 and 1952, 30 Class Y6b engines were produced by the N&W. Engine No. 2200, the last of the Y6bs, is shown here at Roanoke in 1953. (VMT Inc., Archival Collections.)

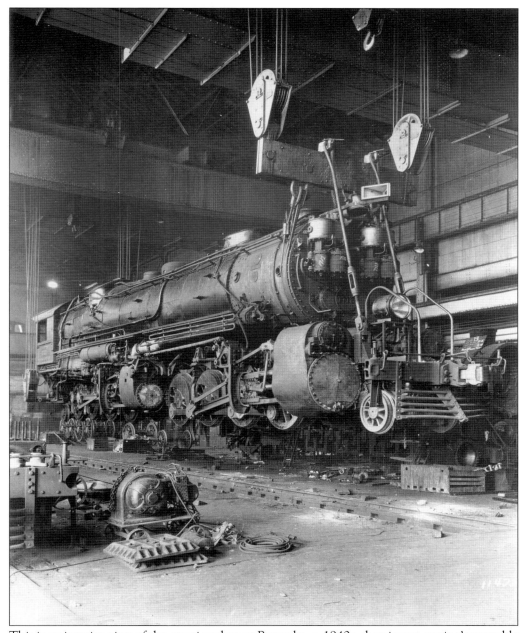

This is an interior view of the erecting shop at Roanoke, *c.* 1940s, showing an engine's assembly in progress.

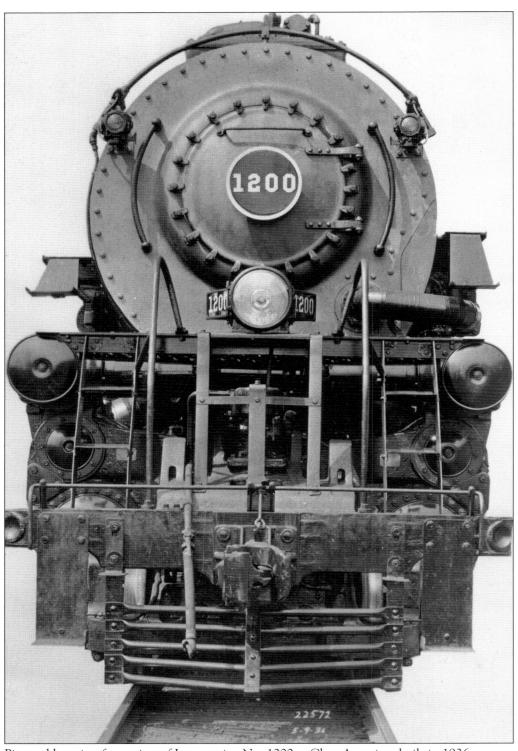

Pictured here is a front view of Locomotive No. 1200, a Class A engine, built in 1936.

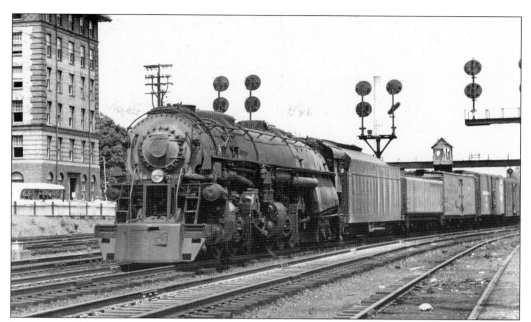

Locomotive No. 1219 arrives in Roanoke in this June 1955 photograph. The Class A was considered to be one of the "Magnificent Three" designs developed by an N&W team headed by J.A. Pilcher, G.P. McGavok, and C.H. Faris. The Class A would break all previous performance records held by N&W engines. (VMT Inc., Archival Collections.)

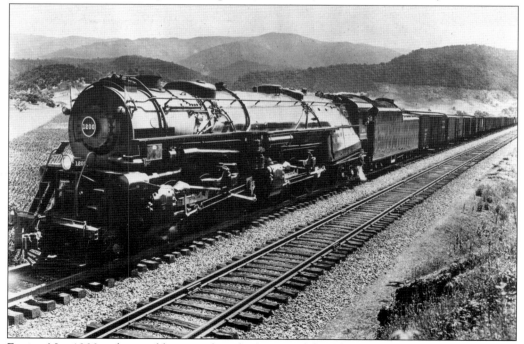

Engine No. 1200 is depicted here on the job. As part of the Class A engines, No. 1200 was the first to be built by the N&W between 1936 and 1950. Maximum horsepower was 6,300 at 45 miles per hour. (VMT Inc., Archival Collections.)

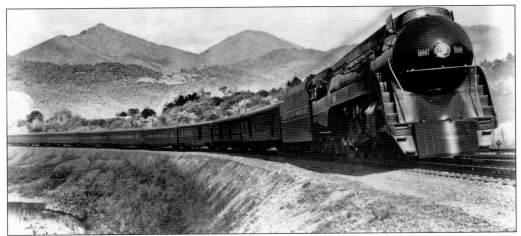

The Class J 600 is pulling a Southern Railway streamlined passenger train. The Class Js were built between 1941 and 1950. (VMT Inc., Archival Collections.)

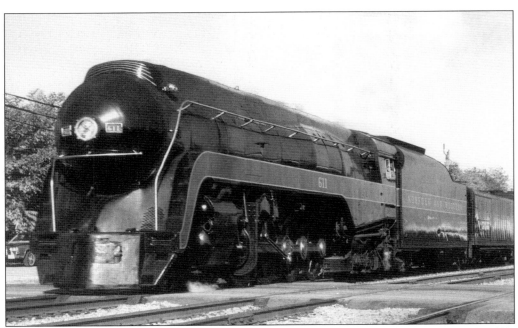

The most endearing design for any locomotive was perhaps that of the Class J. Here is No. 611, which is now on display at the Virginia Museum of Transportation in Roanoke. The Class J design was considered to be the best developed by the N&W prior to the switch to diesel. (VMT Inc., Archival Collections.)

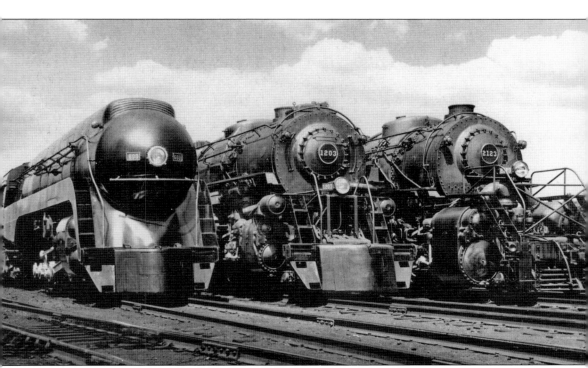

In this often-seen photograph are the three types of modern, coal-burning steam locomotives designed and built by the N&W. These represented the best elements of steam engine design: low initial investment, high utilization, cheap to operate and maintain, and reliable performance. The engines depicted are (from left to right) the J-600, the A-1203, and the Y-2123. (VMT Inc., Archival Collections.)

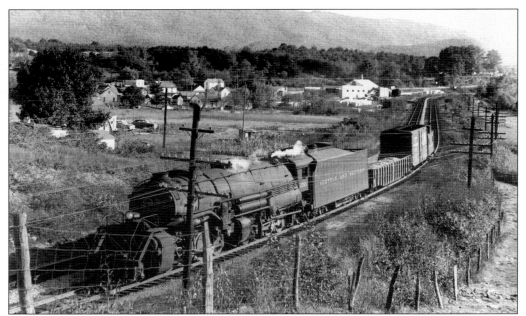

Engine No. 2165 is northbound near Waynesboro, Virginia, in 1956, and hauling a small but varied freight load. (VMT Inc., Archival Collections.)

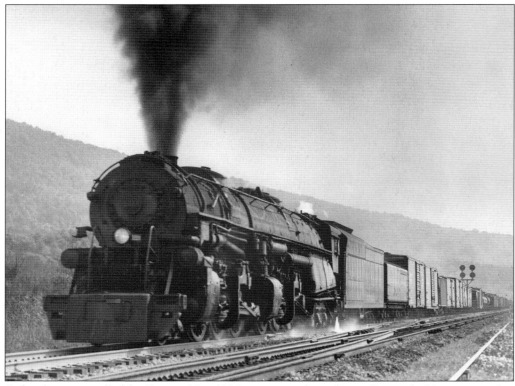

A freight train pulled by Engine No. 1228 moves eastbound near Bonsack, Virginia, in this 1958 photograph. (VMT Inc., Archival Collections.)

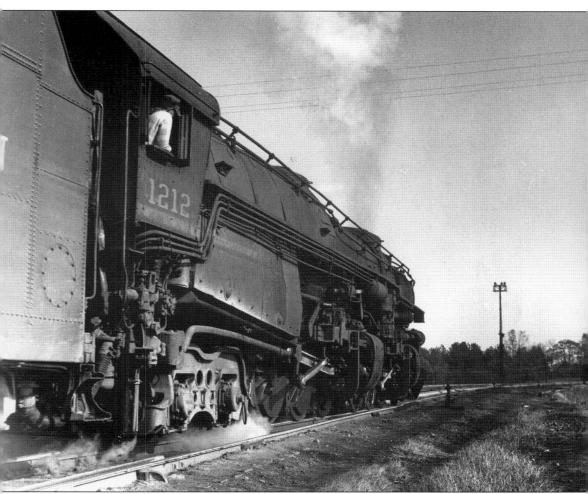

Locomotive No. 1212 pulls a load in a sight no longer seen: a steam engine at work. The N&W was the last major American railroad to abandon the steam engine in favor of the diesel engine. The designers and engineers of the N&W developed the steam locomotive to its highest potential. As one observer noted about the N&W and steam, "No one taught them anything. They were the ones that wrote the book." The last steam engine to be produced by the N&W was a switcher engine that rolled out of the Roanoke Shops in December 1953. The N&W, after 70 years with the steam engine, began buying diesel engines in 1955. The era of steam was over.

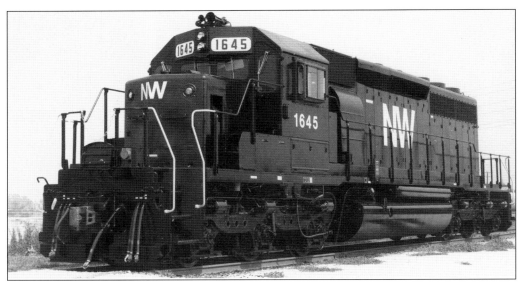

The diesel engine was developed in 1890 by a German named Rudolph Diesel. The Central Railroad of New Jersey was the first to use a diesel locomotive in 1925. It was not until 1955 that the N&W began to order diesel locomotives, primarily from American Locomotive Company and General Motors. Pictured here is a diesel electric locomotive, Engine No. 1645. (VMT Inc., Archives Collections.)

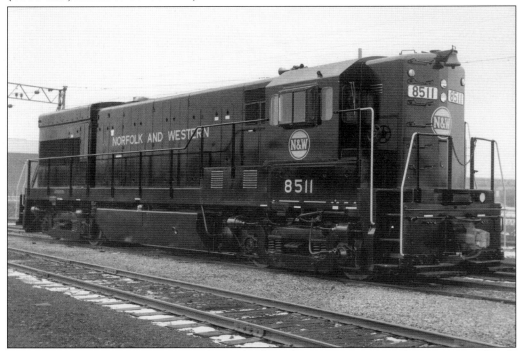

Diesel engines could operate more efficiently than the steam engine, and American railroads were quick to make the switch. Between 1941 and 1955 the number of diesel locomotives being used went from 1,200 to 20,000. Here is an N&W diesel electric locomotive, No. 8511. (VMT Inc., Archival Collections.)

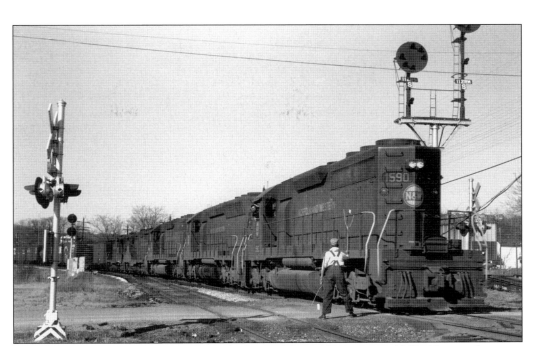

Diesel engine No. 1590 passes through Buena Vista, Virginia, in 1968. Notice the train order raised in order to be grabbed by the engineer as the train passes. (VMT Inc., Archival Collections.)

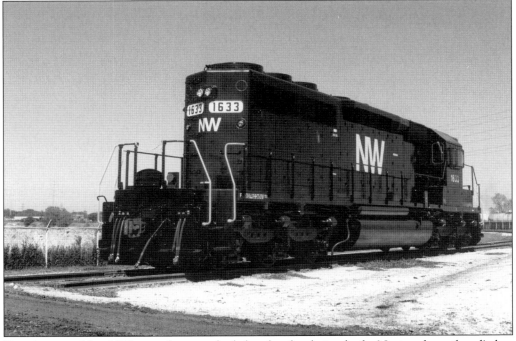

Diesel engine No. 1633 was photographed shortly after being built. Notice the railroad's last corporate logo, the more streamlined "NW." The white-on-black design was introduced by John Fishwick when he was the railroad's president in 1971. (VMT Inc., Archival Collections.)

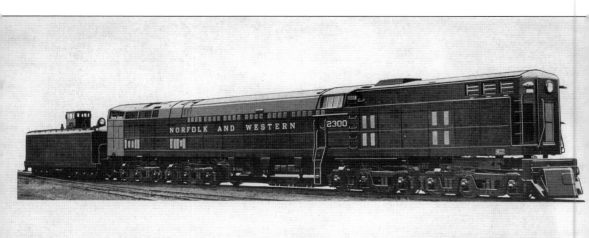

The "Jawn Henry" was the nickname for this combination steam-electric locomotive. It was the N&W's last-ditch effort to give steam one last try. The engine had 12 traction motors, weighed in at 1.1 million pounds, and was 161 feet long. Delivered in 1954, it was classed as TE-1 for turbine-electric. The engine, however, proved flawed. Its high cost, complex control system, inability to fit a standard turntable, and specialized crew demands caused the N&W to retire the engine in 1957. Diesel had won. (VMT Inc., Archival Collections.)

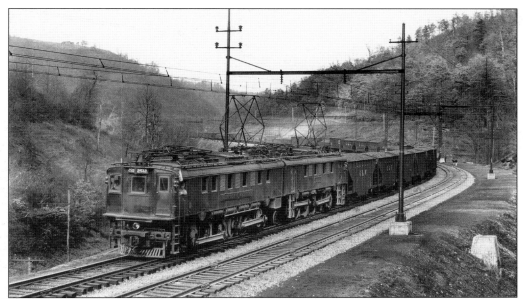

Electric engines were first used widely by the N&W, though they were developed in 1914 so crews could safely navigate the tunnel at Coldale, West Virginia. Moving at slow speeds, the steam engine choked the badly ventilated tunnel to the detriment of the crew's health. The electrified line ran between Bluefield and Hull, West Virginia. Photographed here is an electric engine, No. 2512, on a run in the mid-1920s. (VMT Inc., Archival Collections.)

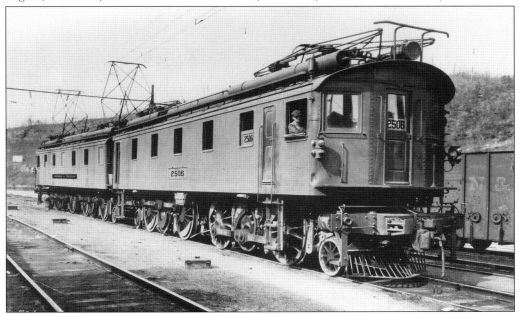

The electric engines acquired by the N&W were from Baldwin-Westinghouse. There were 16 locomotives in all. The system, including overhead catenary wires and a generating plant, was completed in 1916. Engine No. 2506 makes the Bluefield run. In 1950, a new tunnel at Elkhorn was built, altogether eliminating the need for the electric engines by 1950. (VMT Inc., Archival Collections.)

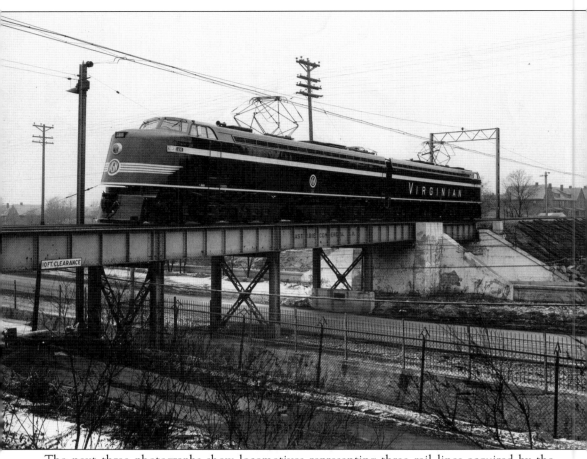

The next three photographs show locomotives representing three rail lines acquired by the N&W during the second half of the last century. The electric locomotive above, No. 126, is from the former Virginian Railway. The Virginian was formed by one man, Henry Rogers, for $30 million in 1907. Having made his fortune in oil, Rogers died a month after the Virginian was officially formed, and his position was assumed by his son. Known for its smooth runs and efficient bottom line, the Virginian made a record 4-hour run from Roanoke to Norfolk in 1918. Three years later it set another record: a coal train of 110 cars carrying 17,050 tons of black gold moved from Roanoke to Sewells Point, the location of its coal pier. In 1958, the N&W approached the Virginian about a merger and the following year the Interstate Commerce Commission approved the sale. At midnight on December 1, 1959, a coal train crossed from the Virginian to the N&W line at Abilene, Virginia, signifying the merger's completion. (VMT, Inc., Archives Collections.)

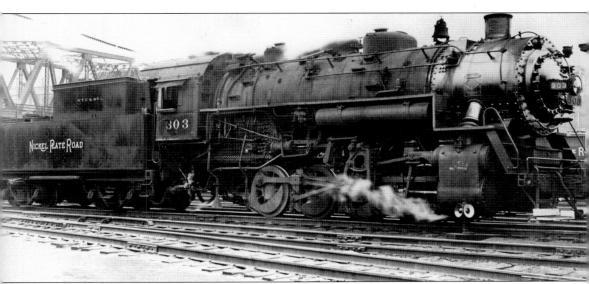

The history of the Nickel Plate Railroad is an amassment of histories from other lines, such as the Lake Erie and Western, Clover Leaf, and the Wheeling and Lake Erie. The Nickel Plate was officially the New York, Chicago, and St. Louis Railroad Company, and it opened for business in the summer of 1882. By 1950, the Nickel Plate had 2,266 miles of track and over 16,000 employees. The N&W approached the Nickel Plate in early 1960 about merger and this was consummated in 1964. A $2,000 investment in Nickel Plate stock in 1947 would have yielded $63,000 at the time of the merger, not counting two decades worth of dividends. Above is Engine No. 303 of the Nickel Plate.

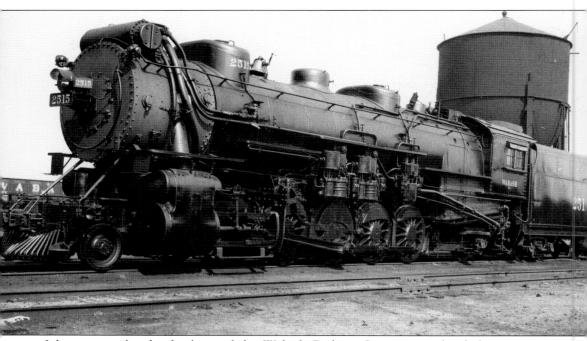

Like many railroads, the lines of the Wabash Railway Company predated the company's formation in 1877. The history of the Wabash is long and complicated, involving certain dubious personalities, mergers, receiverships, and a wavering bottom line. In 1920, Decatur, Illinois, became the hub of the Wabash's activities. In 1931, the Wabash became the first major American railroad to go into receivership due to the Depression. In 1941, it was controlled by Pennsylvania interests. Although solvent, the Wabash was plagued by intense competition and a precarious profit margin. Thus, the Wabash welcomed N&W's leasing of the company in 1964. Above is a photograph of Wabash Engine No. 2515 at the Wabash yard in Decatur on October 2, 1938. (VMT Inc., Archival Collections.)

Four

ROLLING STOCK

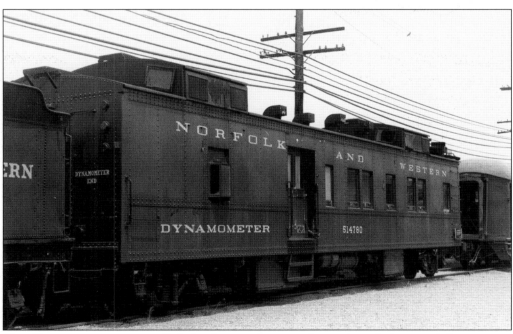

The Dynamometer was pulled by locomotives to determine their actual horsepower and potential speeds. Such calculations were extremely important for efficiently moving freight over differing grades and distances. The ability of the locomotive to do so with speed and climbing power contributed significantly to the N&W's bottom line. (VMT Inc., Archival Collections.)

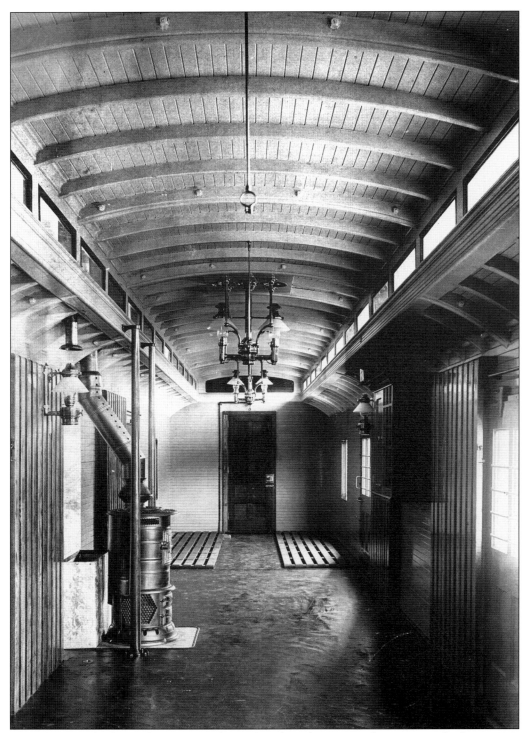

This photograph shows the interior of a 52-foot long baggage and express car built in 1892. Notice the hanging oil lamp and stove at the mid-point. (VMT Inc., Archival Collections.)

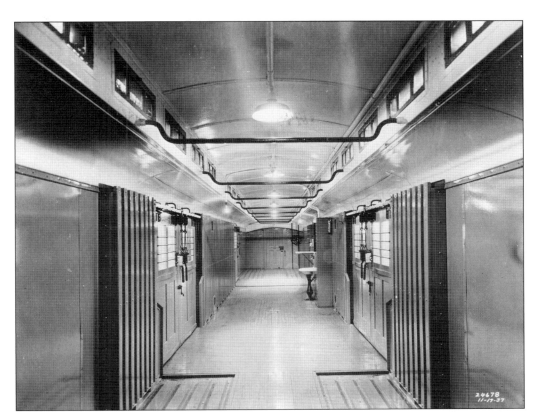

Here is the interior of an express car used by the N&W in 1937. Express cars held all kinds of freight, from passenger baggage to commercial merchandise. (VMT Inc., Archival Collections.)

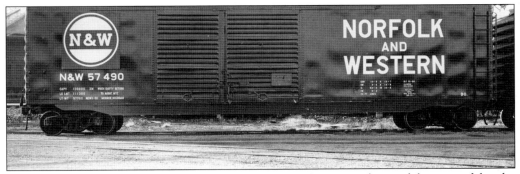

Commonly called the "box car" for obvious reasons, this particular model was used by the N&W in 1960. The small numbers along the side (under the corporate logo) indicated its hauling capacity, weight and load limits, measurements, and when it was built and most recently painted. (VMT Inc., Archival Collections.)

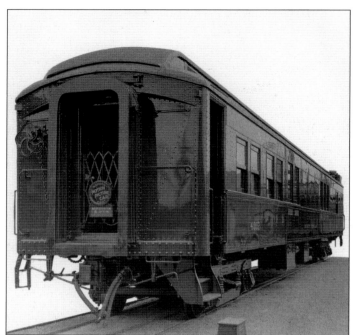

In the late 1920s, the N&W developed a new strategy in rail safety education—the Motion Picture Car. Carrying the "Safety First" logo, the car traveled the various rail lines of the N&W as a mobile classroom for the purposes of providing safety instruction with films. The N&W earned numerous safety awards for its exemplary safety record. This photograph was taken in 1934. (VMT Inc., Archival Collections.)

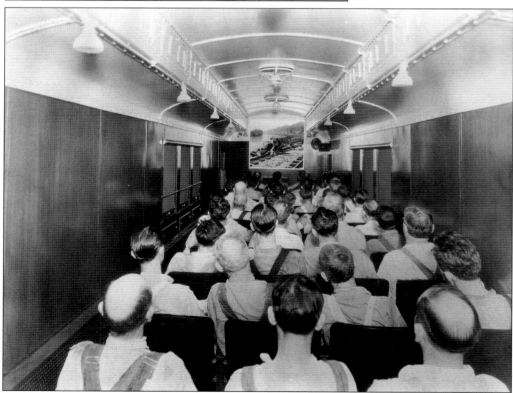

Rail workers watch a safety film inside the N&W's motion picture car. (VMT Inc., Archival Collections.)

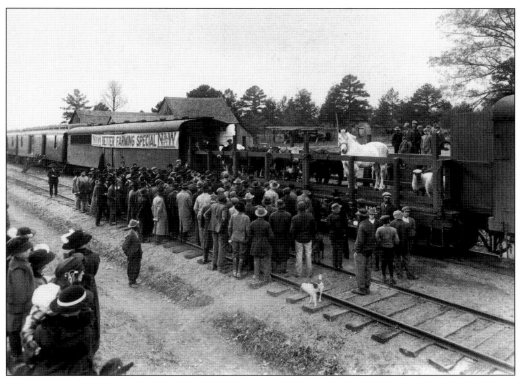

During the first part of the 20th century, the N&W tried to cultivate agricultural products and freight as a possible money-maker. Rail agents often advertised farmland near N&W depots to encourage such activity. Here a "Farm Train" stops as men gather around some stock cars with cattle. A banner reads, "Better Farming Special." The date and location are unknown. (VMT Inc., Archival Collections.)

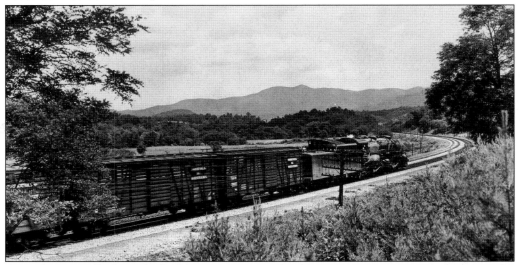

A stock train rolls through the Virginia countryside. As a way to encourage agribusiness, the N&W operated a working farm at Ivor, Virginia, for some years around 1910–1915. (VMT Inc., Archival Collections.)

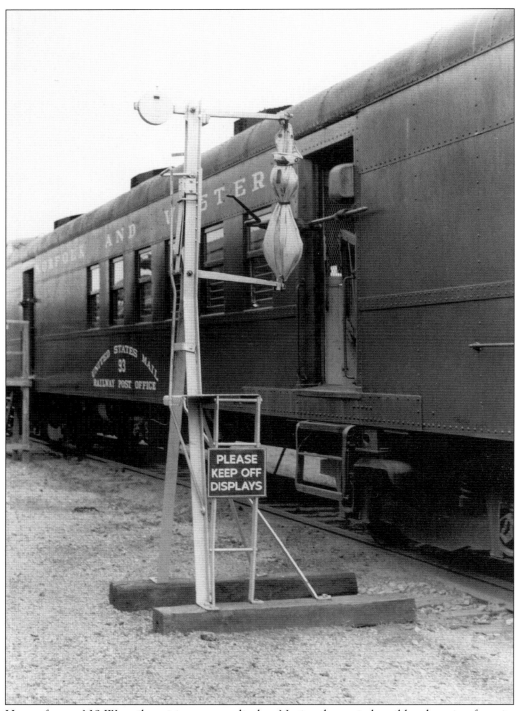

Here a former N&W mail car is a museum display. Notice the period mail bag hanging from its post. As the train would pass, the mail clerk would position the hook, grab the bag, and then begin the sorting process inside the car. (VMT Inc., Archival Collections.)

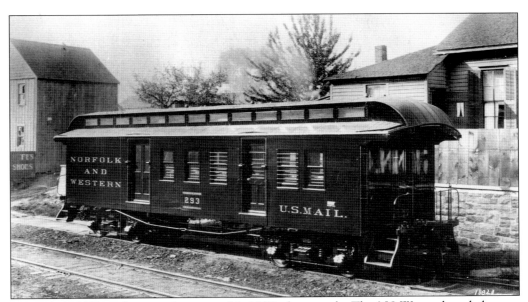

An early N&W mail car is shown in this 1910 photograph. The N&W purchased the car, which was built in 1892. Railroads were a popular and effective way to distribute mail around the country. Clerks aboard the cars would actually cancel the letters en route with the initials "R.P.O.," meaning Rail Post Office. (VMT Inc., Archival Collections.)

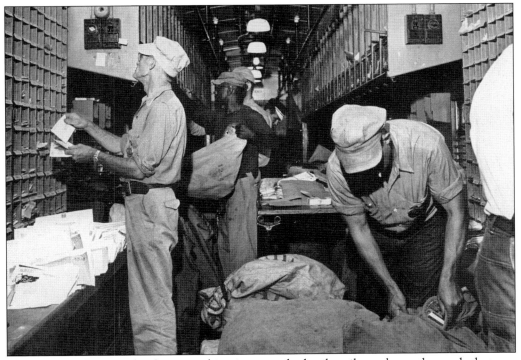

This generic photograph of men working in a standard rail mail car shows the work that was done. The United States Postal Service discontinued use of the railroad post office in 1967. (VMT Inc., Archival Collections.)

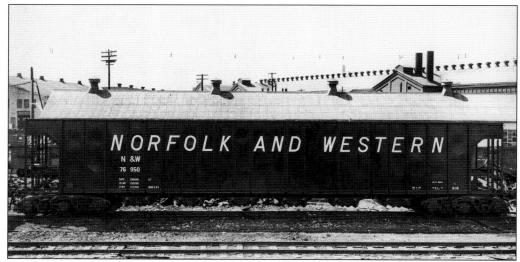

The hopper was the most common type of freight car used by the N&W since its primary purpose was for hauling coal. There were numerous types of hoppers to correlate with the product being moved. This hopper was built in 1963. (VMT Inc., Archival Collections.)

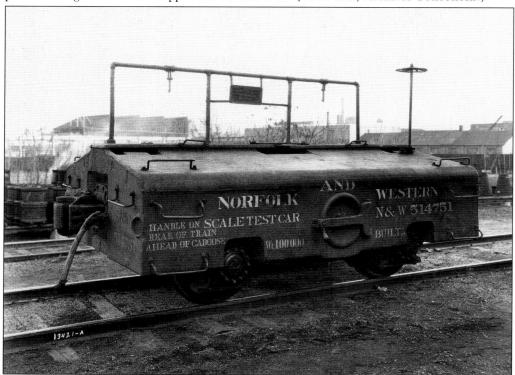

There were some "cars" that were used for tests necessary to properly maintain a railroad track. One such example is the Scaletest Car shown here. The car was used to test the scales on the N&W system that weighed the rolling stock. Instructions on the car read, "Handle on rear of train ahead of caboose." This particular car was built in 1924. (VMT Inc., Archival Collections.)

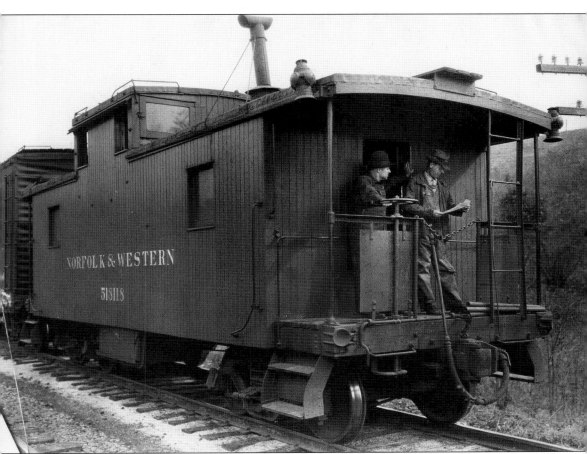

The caboose functioned in many ways as the train's office. Often train orders and other paperwork were handled aboard the caboose, which came on the scene in the late 1800s to serve as living quarters as well as an office for the crew. With the repeal of caboose laws that had mandated their use and since it was a non-revenue car, railroads discontinued its use in the 1980s. (VMT Inc., Archival Collections.)

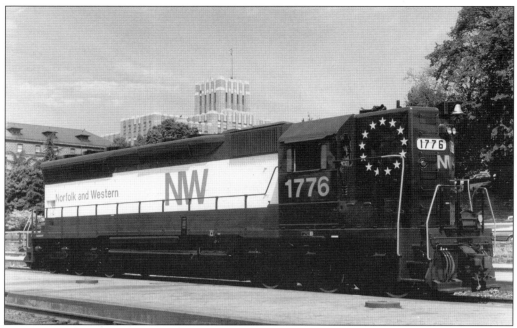

To join in the celebration of the nation's bicentennial, the N&W painted this diesel locomotive red, white, and blue. The engine's number was, appropriately, 1776. (VMT Inc., Archival Collections.)

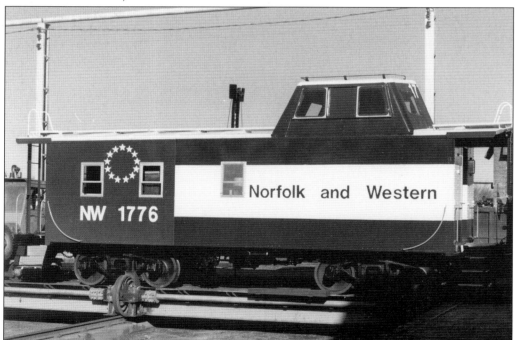

In addition to the Engine No. 1776, the N&W also had painted certain cars within their rolling stock to highlight the Bicentennial. Here a caboose wears the nation's colors. (VMT Inc., Archival Collections.)

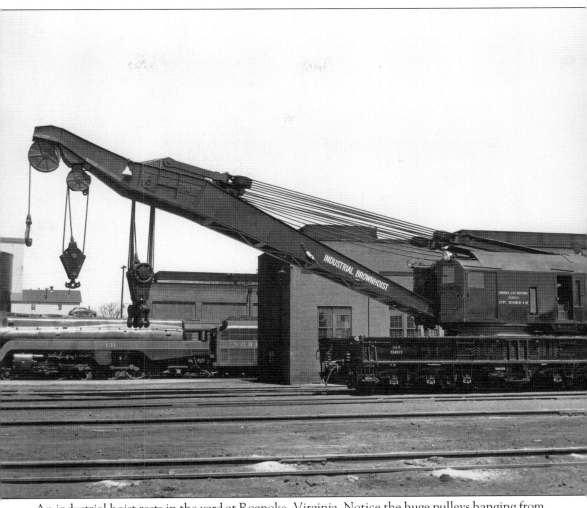

An industrial hoist rests in the yard at Roanoke, Virginia. Notice the huge pulleys hanging from the arm. Engine No. 131 is in the background. (VMT Inc., Archival Collections.)

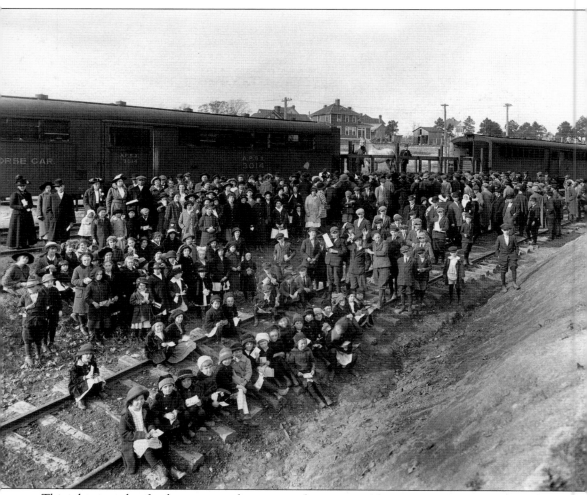

This photograph of a bygone era shows a racehorse car with an auction occurring on the platform car. The photograph was taken by George Davis of Roanoke, which hints at the possible location of the shot (*c.* 1920). There were several racehorse tracks in the Roanoke Valley at that time. (VMT Inc., Archival Collections.)

Five

DEPOTS, STATIONS, AND YARDS

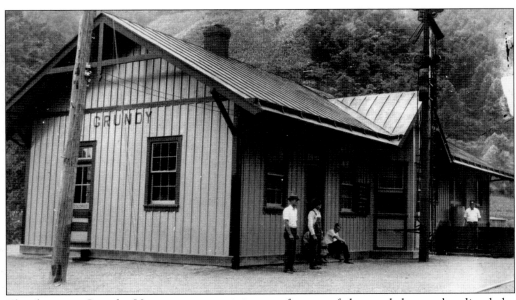

The depot at Grundy, Virginia, was reminiscent of many of the rural depots that lined the tracks of the Norfolk and Western. The date of the photograph is unknown. (VMT Inc., Archival Collections.)

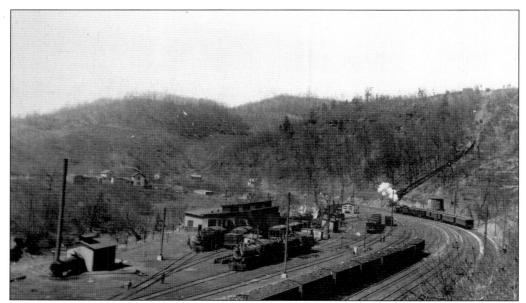

This 1937 photograph shows a small coal yard in West Virginia. The N&W pioneered and developed that state's coal industry. (VMT Inc., Archival Collections.)

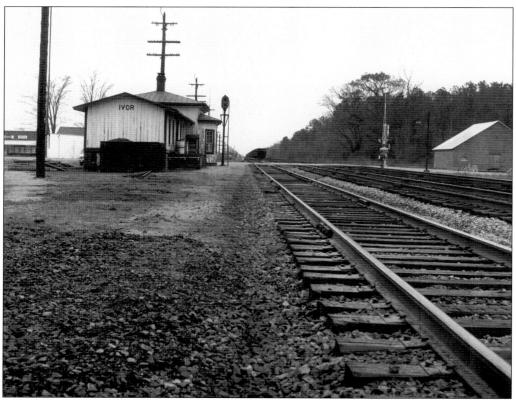

This is the depot at Ivor, Virginia, as it looked in 1964. (VMT Inc., Archival Collections.)

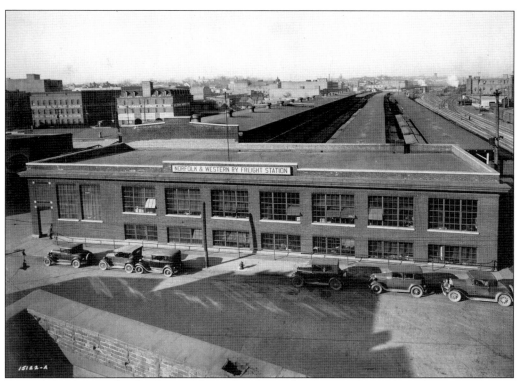

One of the largest freight depots along the N&W line was at Roanoke. These two images above and below show the station as it looked in 1931. Today, the freight depot is home to the Virginia Museum of Transportation, wherein are housed many N&W artifacts and archival material, as well as some steam engines in the outdoor exhibit area. (VMT Inc., Archival Collections.)

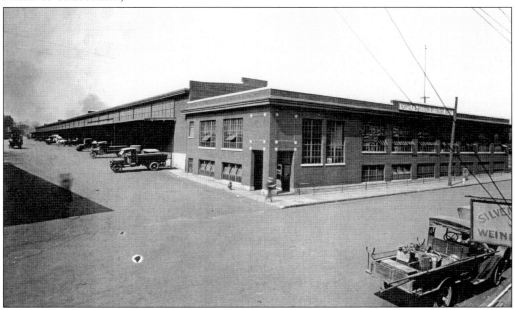

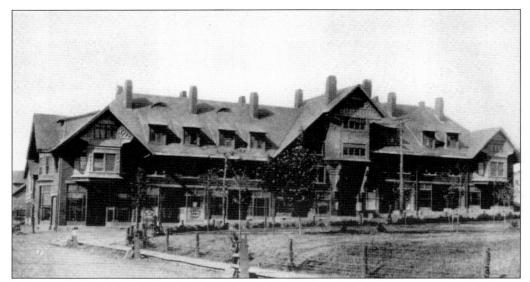

This was the first N&W office building in Roanoke. Unfortunately, the structure caught fire on January 4, 1896. Within less than three hours, the building was in total ruins. The Roanoke newspaper reported that corporate papers were blowing across streets and lawns. In 1896, when the N&W re-organized itself, it changed its name from "Railroad" to "Railway." (VMT Inc., Archival Collections.)

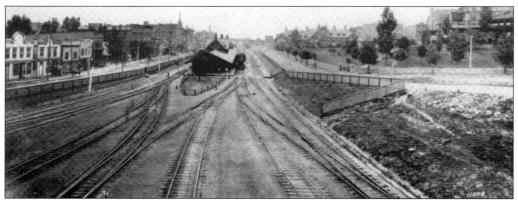

This 1890 view shows the early Roanoke passenger station (center), the N&W office building (center right), and the Hotel Roanoke (right). (VMT Inc., Archival Collections.)

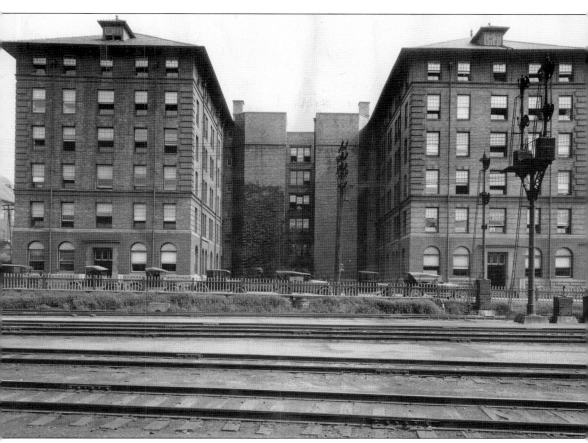

After the first N&W office building burned in 1896, this was the next office building for the railway. It was constructed on the same location. One section was completed in 1896 and the other in 1907. The building still stands and is used for upscale apartments. (VMT Inc., Archival Collections.)

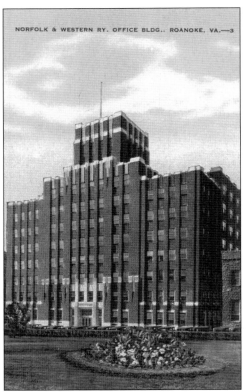

NORFOLK & WESTERN RY. OFFICE BLDG., ROANOKE, VA.—3

The "new" N&W office building in Roanoke was completed in 1930 for $750,000. The building was modeled after the R.J. Reynolds headquarters in Winston-Salem, albeit on a smaller scale. Today, the building is the Roanoke Higher Education Center. (Collection of the author.)

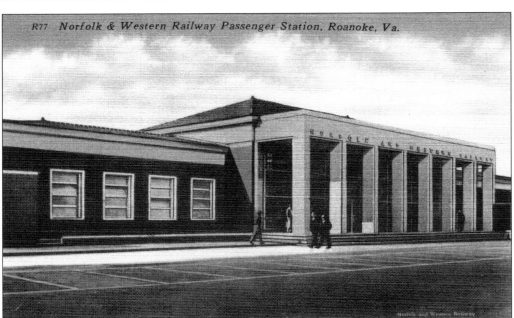

R77 Norfolk & Western Railway Passenger Station, Roanoke, Va.

This 1950 postcard shows the passenger station at Roanoke after being remodeled in 1949. The facility today contains the O. Winston Link Museum, which displays the magnificent black-and-white rail images of the N&W's steam engines. (Collection of the author.)

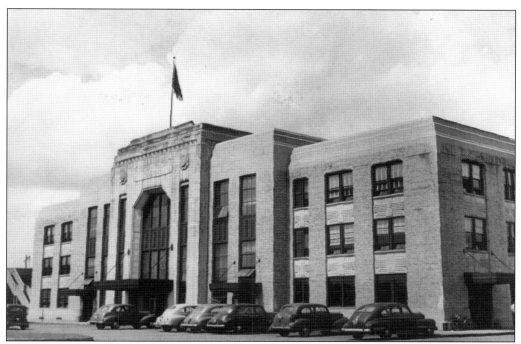

The station at Portsmouth, Ohio, is pictured in 1940. (VMT Inc., Archival Collections.)

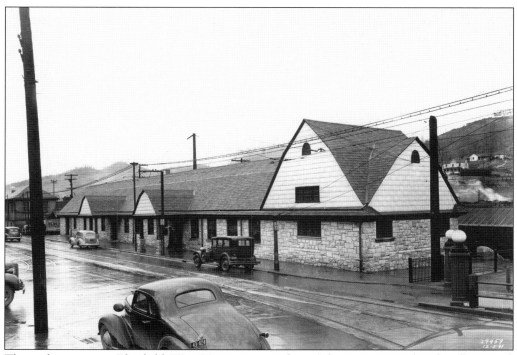

This is the station at Bluefield, West Virginia, around 1935. (VMT Inc., Archival Collections.)

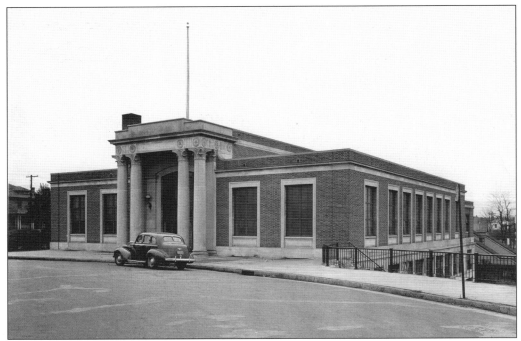

Here is the N&W passenger station at Winston-Salem, North Carolina, as it appeared around 1940. (VMT Inc., Archival Collections.)

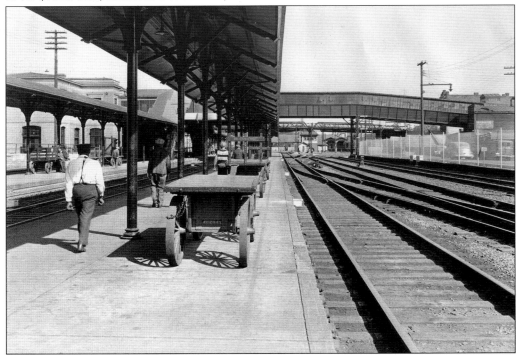

This picture shows the back, lower level of the Roanoke passenger station in 1946, three years before the Raymond Loewy renovation. (VMT Inc., Archival Collections.)

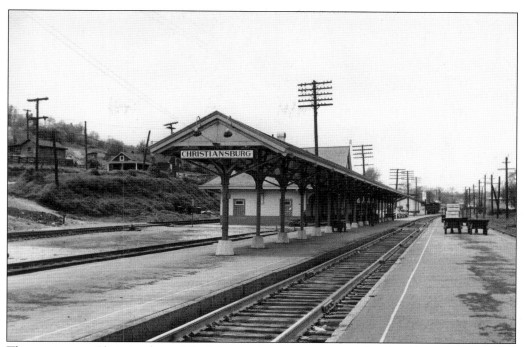

The station at Christiansburg, Virginia, awaits passengers and freight. Note the mail and express carts to the right. (VMT Inc., Archival Collections.)

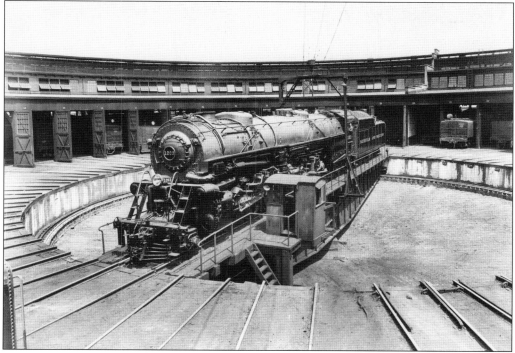

Freight locomotive No. 1203 rests on the turntable at Shaffer's Crossing in Roanoke, Virginia. (VMT Inc., Archival Collections.)

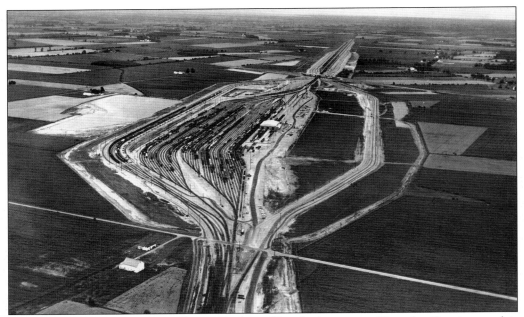

This aerial view shows the Bellevue Yard in Ohio looking east. The classification yard is at left center and immediately to the right is the car repair facility (the building with a white roof is part of it). In the distance are the receiving and departure yards. (VMT Inc., Archival Collections.)

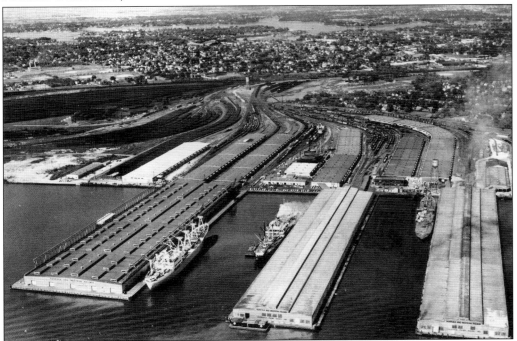

This aerial photograph shows the N&W docks at Lamberts Point, Virginia, near Norfolk. These were freight docks. The railway also operated coal piers at Norfolk, which will be shown in a later chapter. (VMT Inc., Archival Collections.)

Six

PASSENGER SERVICE

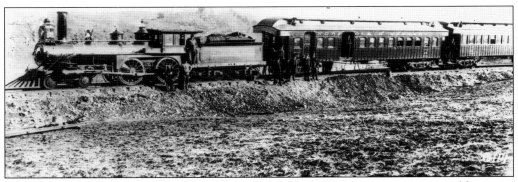

This passenger train stops at Ivanhoe, Virginia, in May 1887. Passenger service would serve as a popular form of distance travel until the emergence of the automobile. (VMT Inc., Archival Collections.)

An N&W passenger train speeds between Roanoke and Christiansburg, Virginia, in 1920. The N&W provided extensive passenger service through southwestern and southeastern Virginia, the Shenandoah Valley, West Virginia, and into parts of North Carolina. With connections, N&W passengers could easily travel from Alabama to New York. (VMT Inc., Archival Collections.)

A passenger train leaves the Roanoke station in 1895. The N&W office building is to the left. (VMT Inc., Archival Collections.)

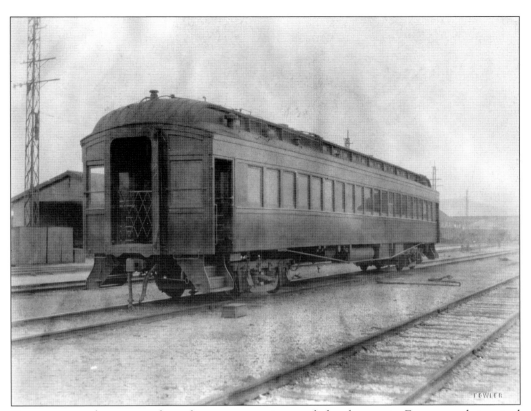

Passenger coaches went through numerous stages of development. From wood to steel construction, and from basic amenities to luxurious accommodations, the coach was designed for both comfort and safety. This is an early passenger coach used by the N&W. (VMT Inc., Archival Collections.)

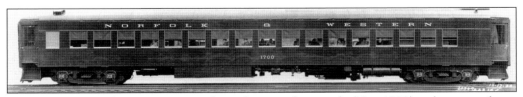

In comparison to the passenger coach at the top, this coach (No. 1700) is longer and can accommodate many more passengers. (VMT Inc., Archival Collections.)

Called a "vestibule car," this interior shot shows passenger seating in an 1892 coach. Notice the window shutters, ornate interior design, and fold-down seats. Despite its comfortable feel, early trains of this era were unsafe and not that pleasant compared with modern service. (VMT Inc., Archival Collections.)

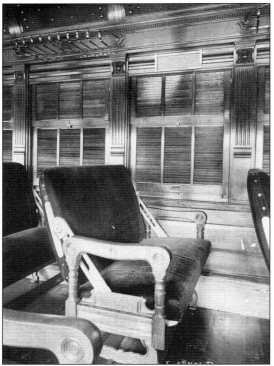

Some three decades later, the passenger coach interior had changed significantly. Here is N&W passenger coach No. 1650 in a photograph dated June 13, 1935. (VMT Inc., Archival Collections.)

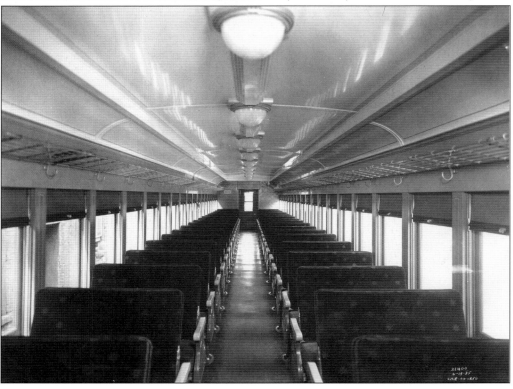

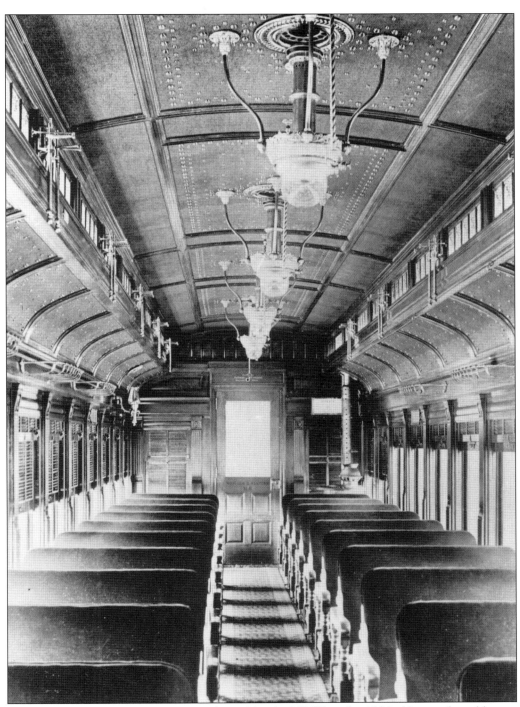

This is the interior of a passenger coach used by the N&W in the 1890s. Notice the oil lamps. Although beautiful design features, these lamps would often shatter during an accident, spilling their fuel into the car. Resultant fires sometimes killed more passengers than the accident's impact. (VMT Inc., Archival Collections.)

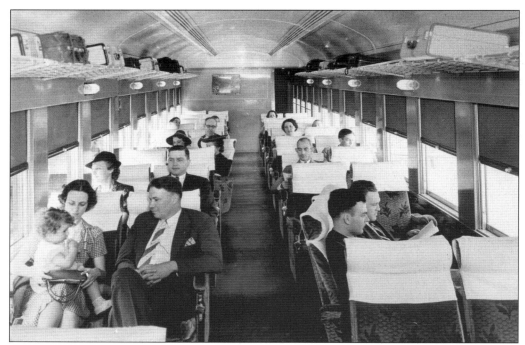

Passengers are enjoying a ride in this N&W coach, which is traveling the rails in June 1938. (VMT Inc., Archival Collections.)

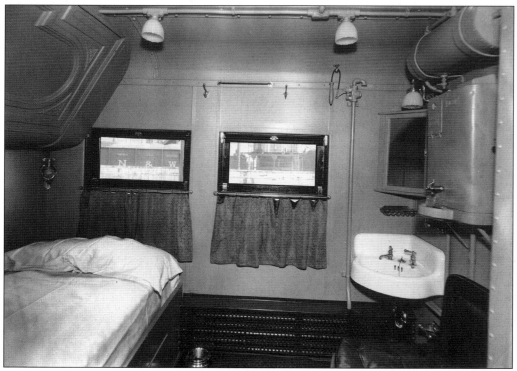

A sleeper car is depicted in this 1930s photograph. (VMT Inc., Archival Collections.)

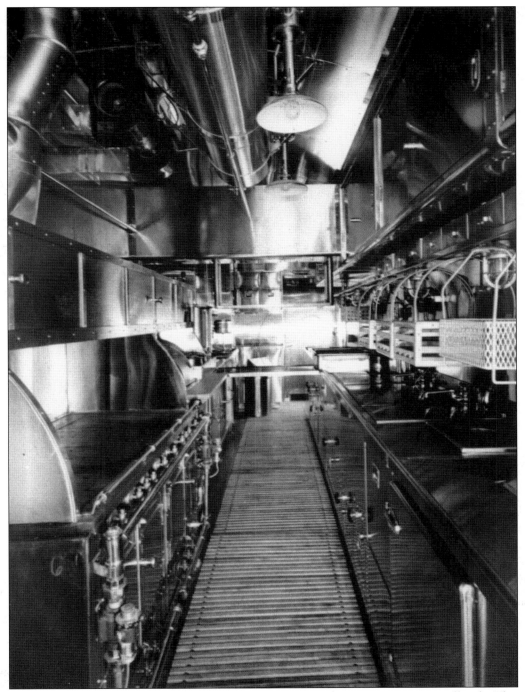

When passenger service encompassed long distances, dining service was offered. This photograph is of a dining car kitchen around 1950. While cooks had to operate in a relatively confined space, they produced full-course meals as good as any fine restaurant. (VMT Inc., Archival Collections.)

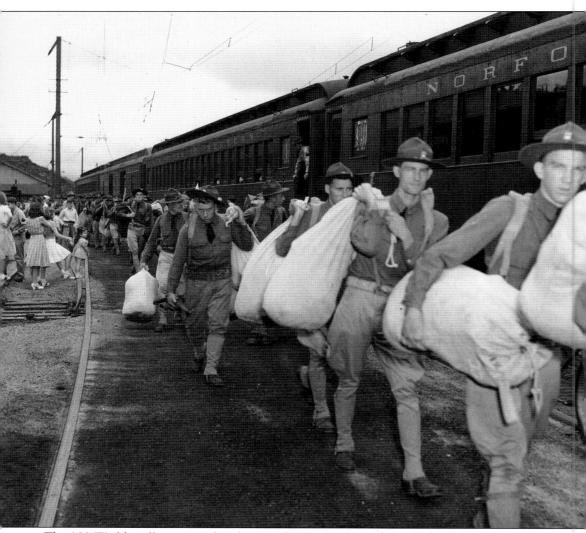

The N&W, like all major railroads, served its country well during World War II for the movement of troops and military freight. In fact, passenger service reached its zenith during wartime. While the exact location of this scene is not known, it certainly represents what was a common occurrence at rail stations across the country—men leaving with family and loved ones bidding them goodbye. In World War I, the Federal government had taken over the railroads to manage military transportation. In World War II, however, the railroads organized themselves, allowing the Federal government to only coordinate, not control, military transportation. During World War II, the N&W moved the most freight in its history. Nearly 10 percent of the N&W's workforce served in the Armed Forces during World War II.

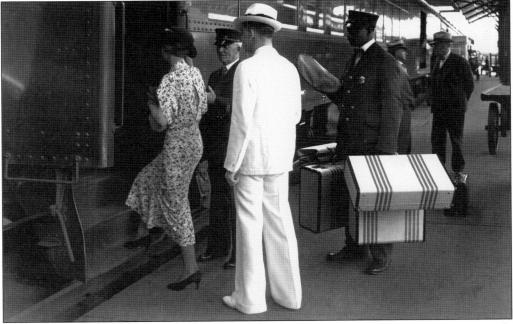

This is the interior of a Pullman car after being made into a sleeper, *c.* 1950. (VMT Inc., Archival Collections.)

Passengers board an N&W coach in this 1947 photograph. Passenger service went into a steady decline after the mid-1940s. In 1946, for example, the N&W carried 3.4 million passengers. By 1950, the figure was about 900,000. The personal automobile was taking its toll on the railroad industry. (VMT Inc., Archival Collections.)

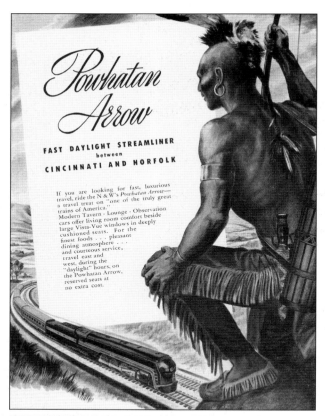

An advertisement promotes the N&W's *Powhatan Arrow*, noting it as the fast daylight streamliner between Cincinnati and Norfolk. The *Powhatan Arrow* made its first west-bound run on April 28, 1946, with a train of tuscan-red cars. (VMT Inc., Archival Collections.)

Here a school group lines up to board the *Powhatan Arrow*. The name for the train had been the result of a contest conducted by the N&W, wherein 140,000 entries were submitted. The winner of the $500 first-place prize was an N&W retiree, Leonard A. Scott. (VMT Inc., Archival Collections.)

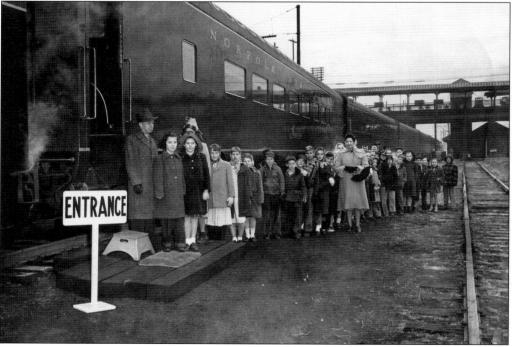

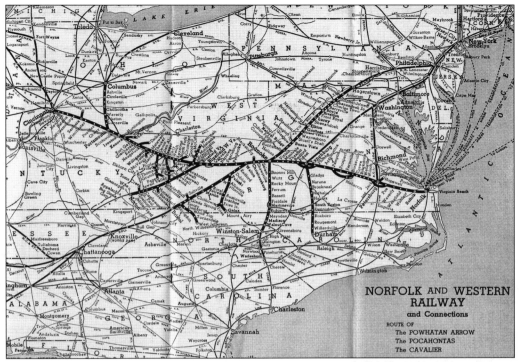

This map shows the routes and connections of the N&W's main passenger trains, *Powhatan Arrow*, *Pocahontas*, and the *Cavalier*. (VMT Inc., Archival Collections.)

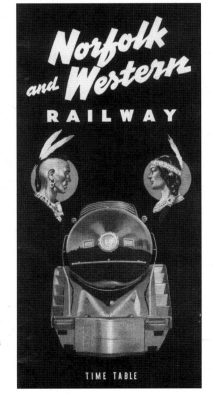

This timetable was for both the *Powhatan Arrow* and *Pocahontas*. Dated September 26, 1948, it displays images long associated with the two lines: the front of a Class J steam engine and the heads of Chief Powhatan and Pocahontas. (VMT Inc., Archival Collections.)

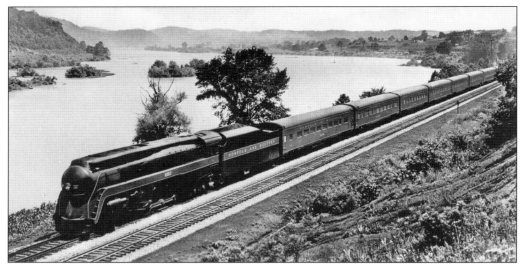

This is the *Powhatan Arrow* on one of its runs in 1948. The *Arrow* traveled along a diverse scenic route through Virginia's Dismal Swamp, the Blue Ridge Mountains, the Alleghanies, and into the West Virginia coal fields. (VMT Inc., Archival Collections.)

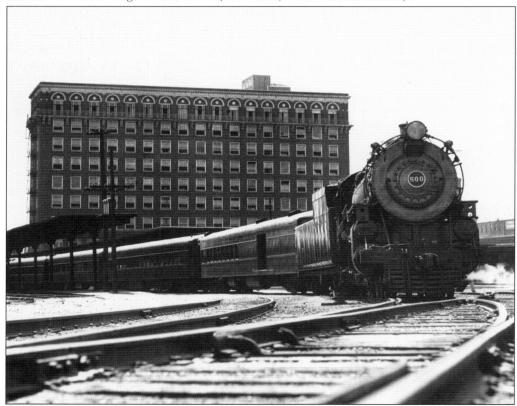

Engine No. 500 pulls out of Norfolk in 1937 with the *Pocahontas*. The *Pocahontas*'s maiden run occurred on November 21, 1926, when she ran between Norfolk and Columbus, Ohio. That run replaced the former "Norfolk-Chicago Express."

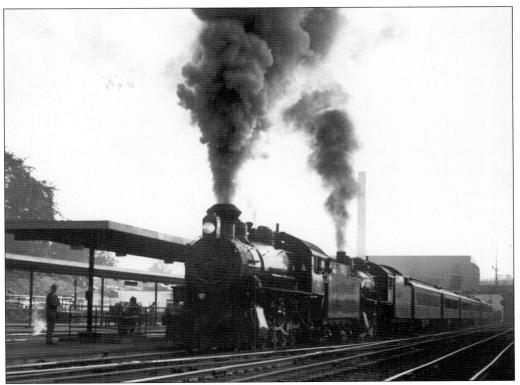

Engine No. 475 steams out of Roanoke in this picture. In 1946, the year most consider to be the beginning of N&W's modern passenger service, an average ridership per train was 118. By 1971, when the N&W discontinued passenger trains, the number had dropped to less than 30. (VMT Inc., Archival Collections.)

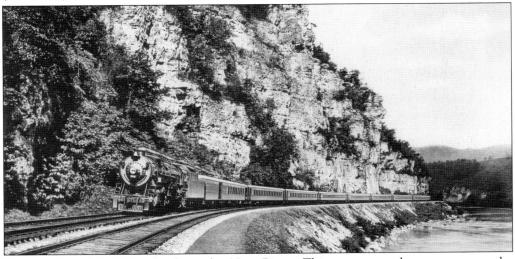

Here the *Pocahantas* travels along the New River. This route was the most spectacular and difficult. After leaving the New River Valley, the *Arrow* climbed abruptly to Bluefield, West Virginia, and then downhill along the Tug River to Williamson. (VMT Inc., Archival Collections.)

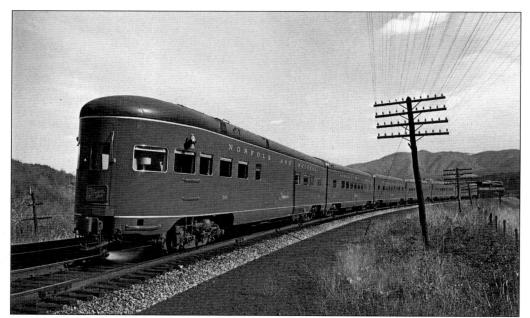

The *Powhatan Arrow* boasted the finest passenger service amenities when introduced, including a tavern-lounge car. Here the *Arrow* moves from Roanoke to Bluefield and was photographed at Singer, Virginia, on December 8, 1949. The round-end tavern car, No. 581, in the consist allowed the *Arrow* to be truly considered as a "streamliner."

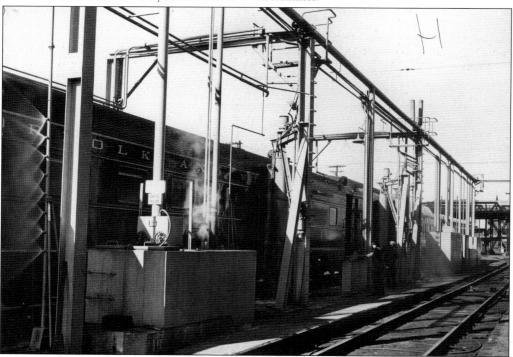

To keep the passenger coaches looking good, the railroad regularly sent them through a mechanical washing facility, shown here. (VMT Inc., Archival Collections.)

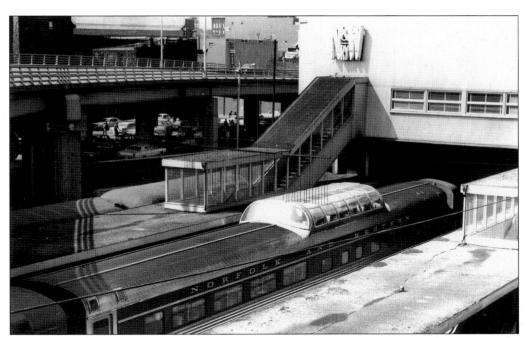

This photograph was taken at the Roanoke passenger station in September 1969. The *Birmingham Special* is in the background and the *Pocahontas* is in the foreground. (William E. Warden/VMT Inc., Archival Collections.)

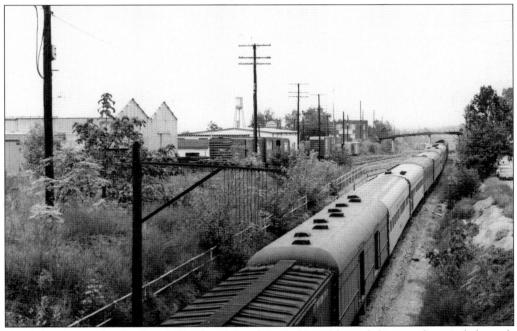

On September 2, 1969, the *Birmingham Special* moved northbound, having detoured through Waynesboro, Virginia, on account of a washout on the Southern Railway's main line between Monroe and Charlottesville, Virginia. The *Special* was among a number of other passenger trains operated by the N&W. (William E. Warden/VMT Inc., Archival Collections.)

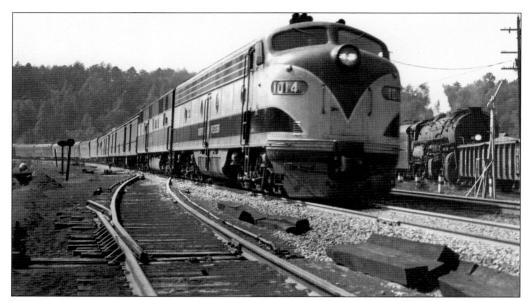

The *Pocahontas* moves eastbound through Blue Ridge, Virginia, in September 1959. Diesel No. 1014 pulls her. The engine, though bearing the N&W name, was a diesel originally belonging to the Richmond, Fredericksburg, and Potomac. By the late 1950s, as the N&W was transitioning to diesel, a number of RF&P engines were being used by the N&W for its passenger trains. (William E. Warden/VMT Inc., Archival Collections.)

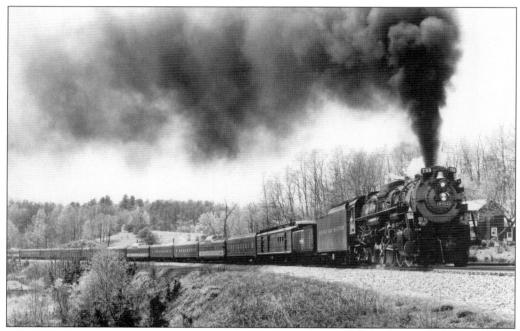

The N&W's passenger service said farewell in 1971. Here is the *Pocahontas* on her last run, traveling eastbound at Blue Ridge, Virginia, on May 1, 1971. An estimated 100,000 spectators lined the route to catch a last glimpse of an era passing. (William E. Warden/VMT Inc., Archival Collections.)

Seven

BLACK GOLD

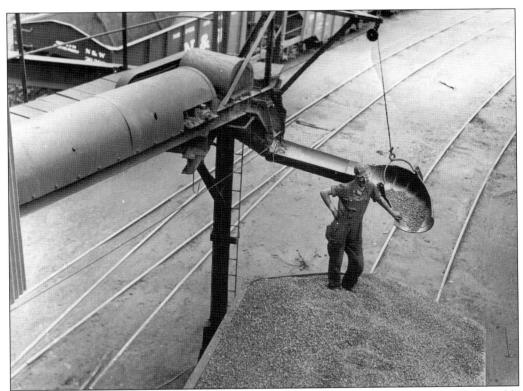

Coal quickly became the N&W's leading freight commodity. It truly was "black gold" for the railway. Here an employee loads a N&W hopper with coal, c. 1945. (VMT Inc., Archival Collections.)

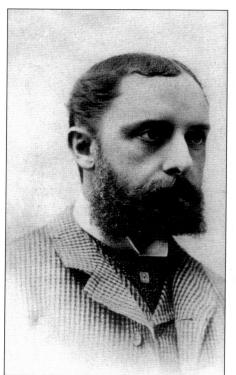

Frederick J. Kimball was one of the most forward-thinking of the early N&W presidents. He was so respected the citizens of Big Lick, Virginia, voted to change the town's name to Kimball in his honor. He declined and suggested the location be called Roanoke, which it became in 1882. At 38, he was president of the Shenandoah Valley Railroad when he was tapped to be the N&W's first chief operating officer. He then served as the N&W's president or chairman for 20 years from 1883 until his death at 59 in 1903. Kimball was interested in the coal fields of West Virginia, and on a weekend trip in May of 1881, Kimball, his wife, and others journeyed to the state. At Abb's Valley, Kimball viewed a 12-foot coal vein visible along the surface. Digging a piece out with his penknife, Kimball turned to his wife and uttered perhaps the greatest understatement in the history of the N&W: "This may be a very important day." Kimball's wife suggested the vein be called "Pocahontas." (VMT Inc., Archival Collections.)

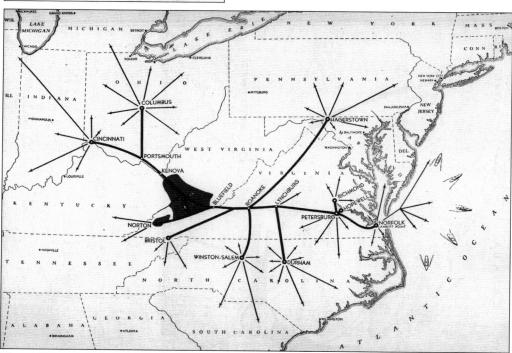

This 1970s map shows the coal distribution network operated by the N&W. The shaded territory shows the coal fields developed by the railway. (VMT Inc., Archival Collections.)

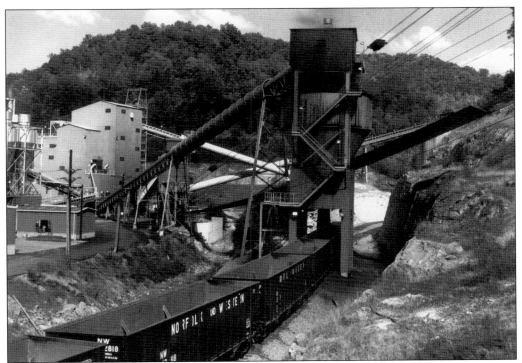

N&W hoppers at a West Virginia coal tipple are loaded for their eastbound trip to Lamberts Point near Norfolk. In 1883, the N&W moved nearly 106,000 tons of coal. A century later, the N&W moved 75 million tons annually. (VMT Inc., Archival Collections.)

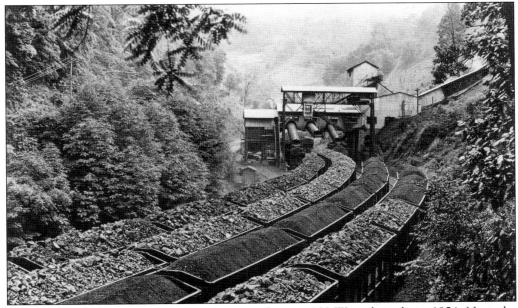

These are loaded coal cars awaiting shipment from an N&W coal tipple in 1954. Note the different grades of coal being loaded. During World War II, the United States Navy almost exclusively used N&W coal for its Atlantic fleet. (VMT Inc., Archival Collections.)

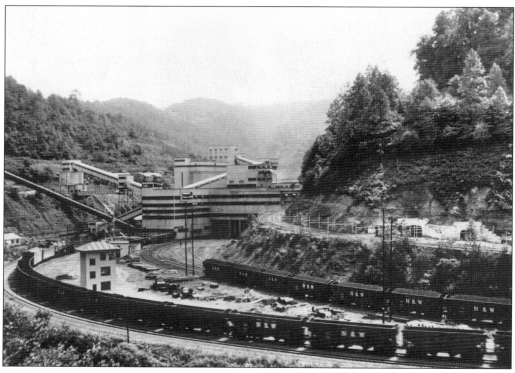

Freight cars line up outside a coal-cleaning and prep plant near Gary, West Virginia, in this mid-1950s photograph. The N&W relied havily on many of the larger coal mines and facilities throughout West Virginia. (VMT Inc., Archival Collections.)

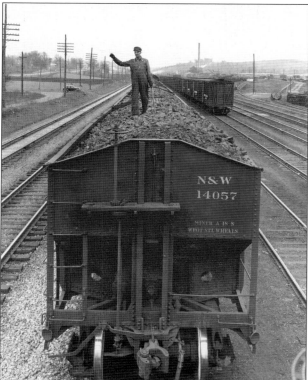

A hopper with coal is ready to go. The year 1970 was the peak for N&W coal traffic, when the railway carried 90.6 million tons of coal. While coal was profitable, it was not always a consistent source of revenue. Floods, miner strikes, and other labor disputes cut deeply into N&W's coal traffic. During the 1978 strike of the BRAC, for example, the amount of coal hauled dropped to 47 million tons. (VMT Inc., Archival Collections.)

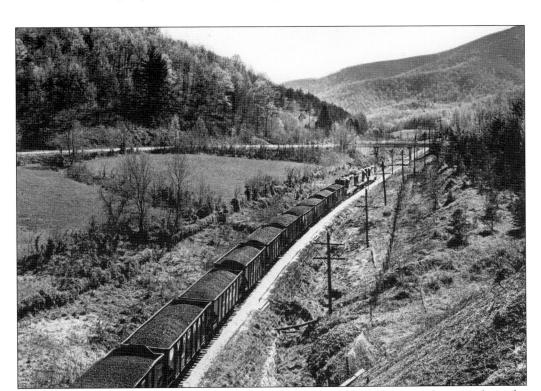

This picture shows coal on its way. Notice this consist also includes some hoppers from the Virginian Railway, which had been acquired by the N&W in 1959. This photograph was taken in the mid-1960s. (VMT Inc., Archival Collections.)

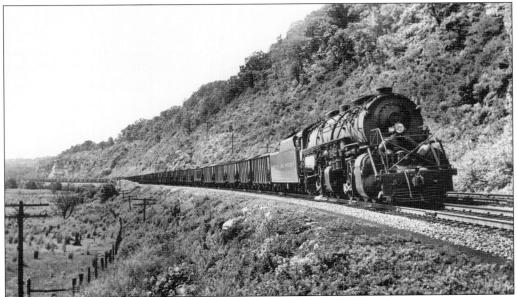

Engine No. 2146 pulls coal in this 1949 image. In the 1940s, the N&W served the following seven coal districts: Kenova, Thacker, Tug River, Pocahontas, Clinch Valley 1 and 2, and Radford. (VMT Inc., Archival Collections.)

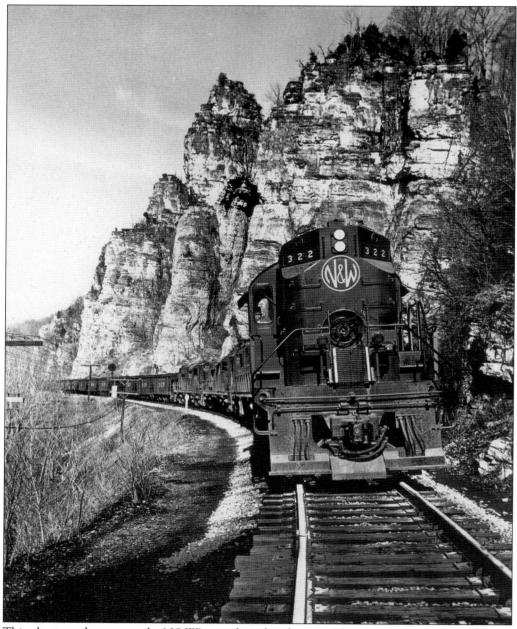

This photograph captures the N&W's switch to diesel power. The change to diesel was difficult for the N&W given its commercial investment in coal. Here this "new" 1,800-horsepower engine pulls a consist through Virginia. (VMT Inc., Archival Collections.)

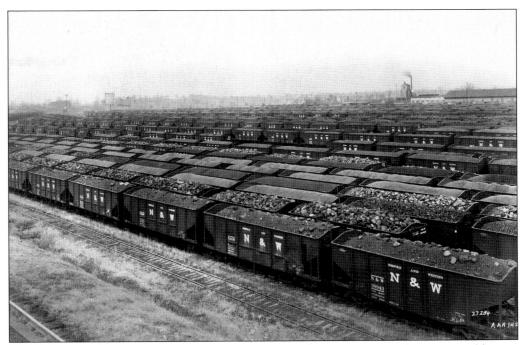

This is the view across the flat yard at Norfolk, Virginia, c. 1950. Here hoppers would await being emptied. (VMT Inc., Archival Collections.)

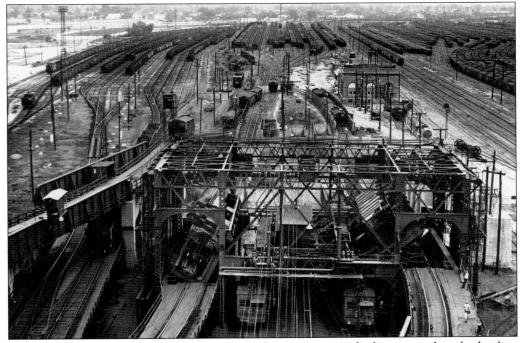

At coal pier #4 at Norfolk, hoppers are dumped into pier cars which carry coal to the loading shutes. In the background is a portion of the N&W's 12,000 car classification and storage yards, c. 1950. (VMT Inc., Archival Collections.)

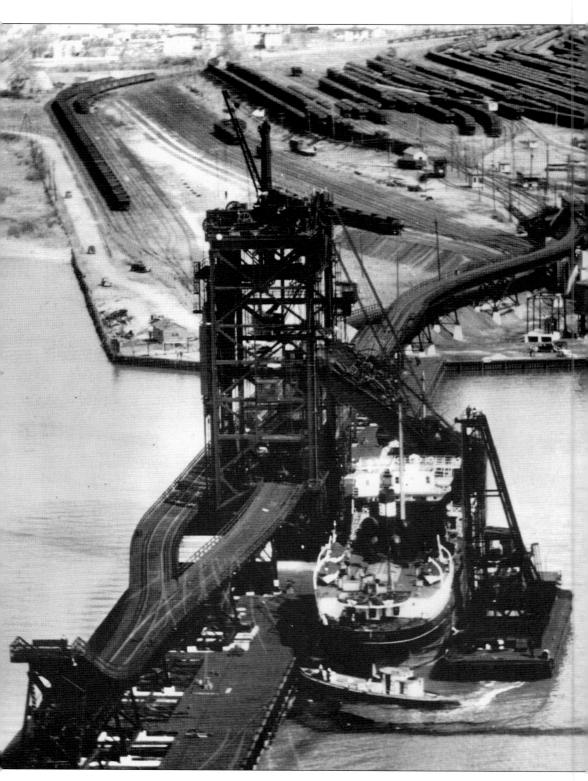

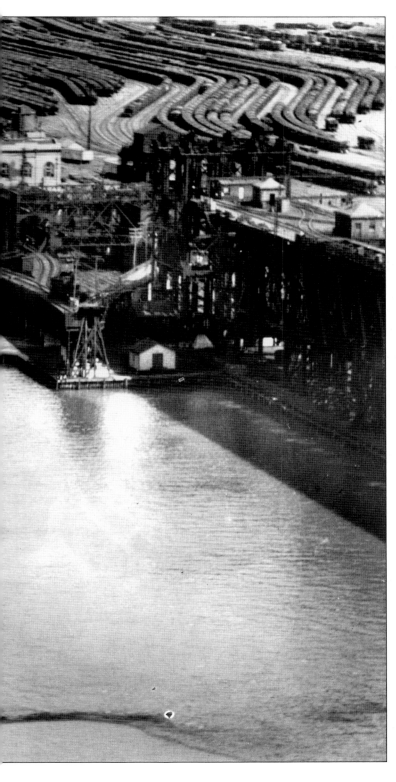

The N&W shops always kept a spare for *every* part necessary so the above activity could remain operational. (VMT Inc., Archival Collections.)

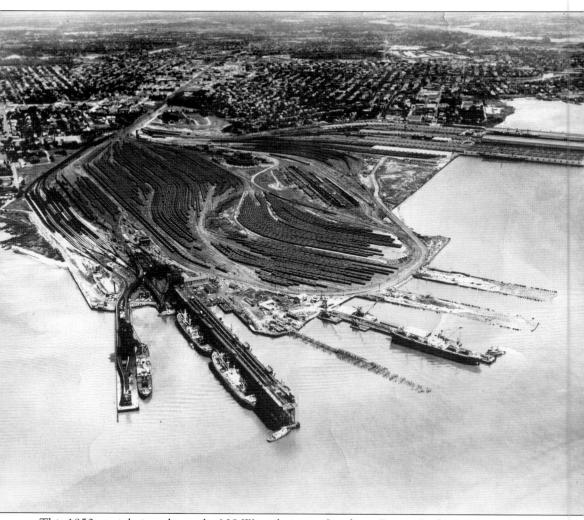

This 1950s aerial view shows the N&W coal piers at Lamberts Point. Coal pier No. 4 is center and was built in 1914. At the time of its initial construction, the pier was 1,200 feet long, 70 feet wide, and 90 feet above the water. It could empty 600 cars a day. Pier 4 was "retired" in 1963, having loaded some 200 million tons of coal since its first day of operation in 1914. In September 1963, Pier 6 took over for Pier 4. (VMT Inc., Archival Collections.)

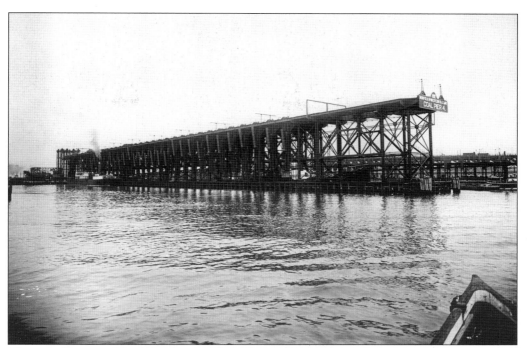

This is a close-up of Coal Pier 4 at Lamberts Point. The pier served the N&W for nearly a half century. (VMT Inc., Archival Collections.)

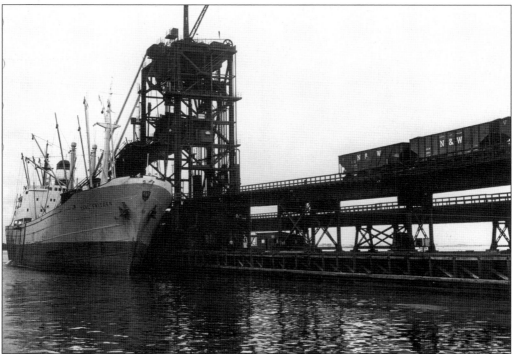

Loaded coal cars are awaiting their turn at the car-dumping machine. Upwards of 400 cars of coal are required to fill the larger colliers. (VMT Inc., Archival Collections.)

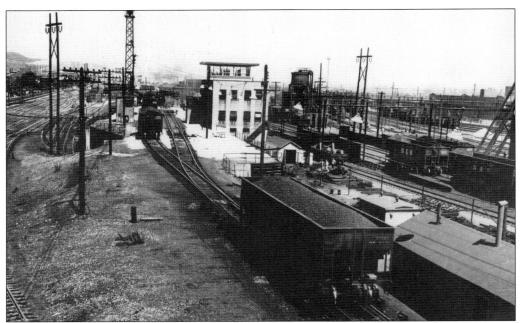

Not all coal was exported. Here a hopper car loaded with coal coasts down the "hump" incline toward classification tracks at the Portsmouth, Ohio, freight yard. The car is half-way through the master retarder. The scale house and assistant yard master's office are located in center of the photograph, c. 1950. From this yard, coal would go to distribution points at Columbus and Cincinnati. (VMT Inc., Archival Collections.)

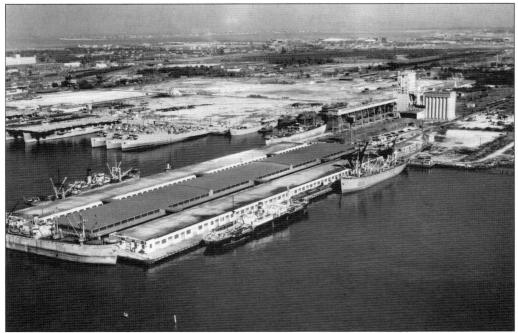

Coal was not the only export transported by the N&W. This image shows freight docks and a grain elevator at Sewalls Point. Pier A is center foreground. (VMT Inc., Archival Collections.)

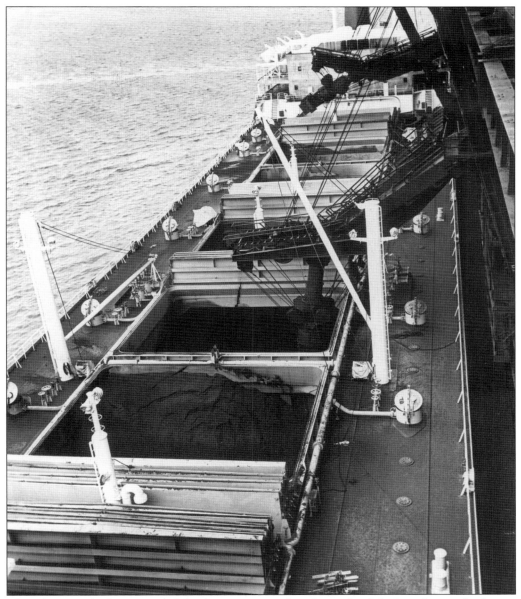

This photograph shows one of the largest cargo of coal ever loaded aboard a single ship at Lambert's Point. A total of 493 carloads were required. (VMT Inc., Archival Collections.)

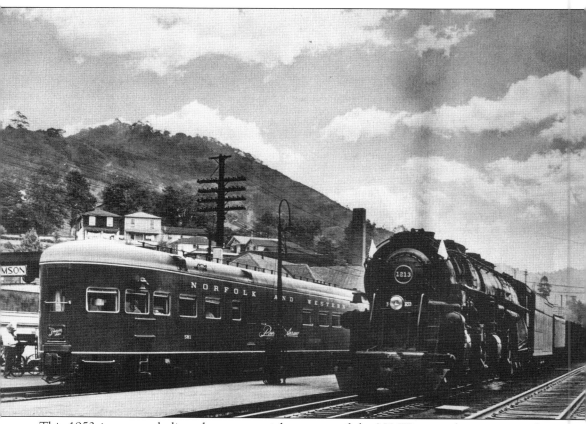

This 1953 image symbolizes the commercial ventures of the N&W—a coal train enters the picture as a passenger train, the *Powhatan Arrow*, leaves. Engine 1213 is westbound out of Williamson, West Virginia, to deliver coal to the Great Lakes region. The engine is a Class A with an auxiliary water tank, allowing it to run non-stop between major terminals. The *Arrow* is on its eastbound run from Cincinnati to Norfolk.

FURTHER READING AND RESEARCH

Corporate History of the Shenandoah Valley Railway Company: Maryland and Washington Division of the Norfolk and Western Railroad. Philadelphia: Allen, Lane & Scott, 1891.

Cox, Richard E. *Norfolk and Western Railway, Volume I*. Sacramento, California: Vanishing Vistas, 1985.

Helvestine, Frank. "History of the Norfolk and Western Railway." *N&W Magazine*, 1923–1926, Volumes 1–4.

Jeffries, Lewis Ingles. *Norfolk and Western: Giant of Steam*. Boulder, Colorado: Pruett Publishing, 1980.

Lambie, Joseph T. *From Mine to Market: The History of Coal Transportation on the Norfolk and Western Railway*. New York: New York University Press, 1954.

Link, O. Winston. *The Last Steam Railroad in America*. New York: Harry A. Abrams, Inc., 1995.

Night Tricks: Photographs of the Norfolk and Western Railway, 1950–1960. London: The Photographers Gallery, 1983.

Steam, Steel and Stars: America's Last Steam Railroad. New York: Abradale Press, 1987.

Powered By People. Roanoke, Virginia: The Norfolk and Western Railway, 1958.

Prince, Richard E. *Norfolk and Western Railway—Pocahontas Coal Carrier*. Millard, Nebraska: Privately Published, 1980.

Smith, Robert H. *General William Mahone, Frederick H. Kimball and Others: A Short History of the Norfolk and Western Railway*. New York: Newcomen Society of America, 1949.

Striplin, E.F. Pat. *The Norfolk & Western: A History*. Roanoke, Virginia: Norfolk and Western Railway Company, 1981.

Warden, William E. *Norfolk and Western Railway A and J-Class Locomotives*. Nashville: Andover Junction Publications, 1987.

Norfolk and Western Passenger Service, 1946–1971. Lynchburg, Virginia: TLC Publishing, 1990.

Webb, Munsey W. *Norfolk and Western Railway Company North Carolina Branch*. Privately published, 1995.

Withers, Paul K. and Robert G. Bowers. *Norfolk and Western Railway: First Generation Diesels*. Halifax, PA: Withers, 1985.

Norfolk and Western Railway: Second Generation Diesels. Halifax, Pennsylvania: Withers, 1989.

Norfolk and Western Historical Society
P.O. Box 13908
Roanoke, Virginia 24038

Virginia Museum of Transportation
303 Norfolk Avenue
Roanoke, Virginia 24016

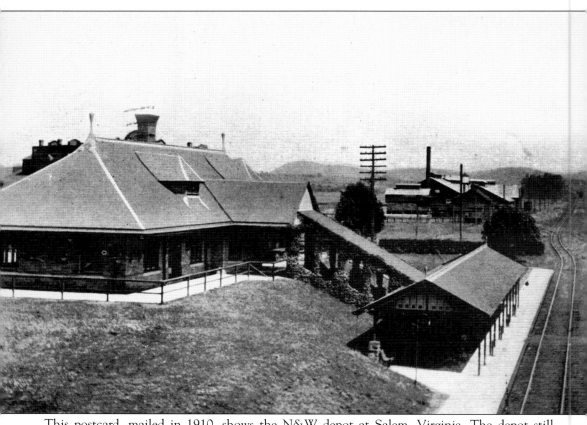

This postcard, mailed in 1910, shows the N&W depot at Salem, Virginia. The depot still remains, although the shed at the tracks was dismantled many years ago. During the 1930s, depots like this dotted the lines of the N&W. Few remain today, either abandoned or in alternative uses, as reminders of the great era of the Norfolk and Western Railway.